COLLINS

CHROMACOLOUR

• A REVOLUTION IN ART •

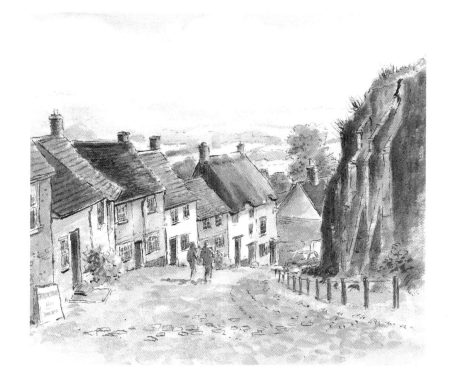

CHROMACOLOUR

• A REVOLUTION IN ART • DON HARRISON •

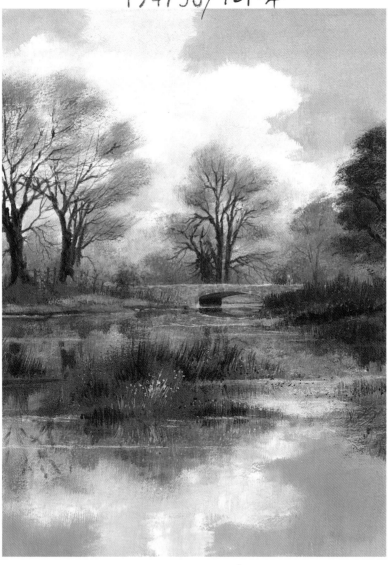

HarperCollins*Publishers*

Acknowledgements

In particular I would like to thank Jon Prudence of Chromacolour International for his invaluable help and advice in compiling much of the information in this book. I would also like to thank the talented guest artists who were kind enough to find time to produce text, transparencies and, in many cases, original work for inclusion in the book. Finally, my appreciation to HarperCollins (and their very patient staff) for their foresight in publishing the first complete book on Chromacolour.

First published in 1996 by
HarperCollins Publishers, London

A catalogue record for this book is available from the British Library

EDITOR: Geraldine Christy
DESIGN MANAGER: Caroline Hill
DESIGNER: David Stanley
PHOTOGRAPHER: Jon Bouchier

ISBN 0 00 412989 X

Set in Century Condensed and Helvetica
Colour reproduction by Colourscan, Singapore
Produced by HarperCollins Hong Kong

PAGE 1: Don Harrison, *Gold Hill, Shaftesbury*, 255 × 270 mm (10 × 10½ in)
PAGE 3: Don Harrison, *Spring Morning*, 360 × 260 mm (14 × 10¼ in)

Contents

Introducing Chromacolour

Most artists spend their lives seeking inspiration in some shape or form. Some find satisfaction in producing pleasant, if uninspired, work using the same trusty techniques and traditional paints over and over again. Others constantly search for new directions in their art or new materials and media with which to expand and exploit their creative energies and feelings. Many, especially leisure painters, see art as a relaxing therapy against the stresses and strains of present-day life or as an enjoyable pastime often spent in the company of like-minded people.

In general, artists seek constantly to improve the standard of their work and anything that may help them produce more worthwhile and satisfying results is welcomed. Every once in a while a new medium is introduced, but after an initial flurry of enthusiasm is soon forgotten. In recent years, however, an unusual paint of more lasting interest has become available to both amateur and professional artists. The paint is called Chromacolour, and its appearance heralds the start of a revolution in art.

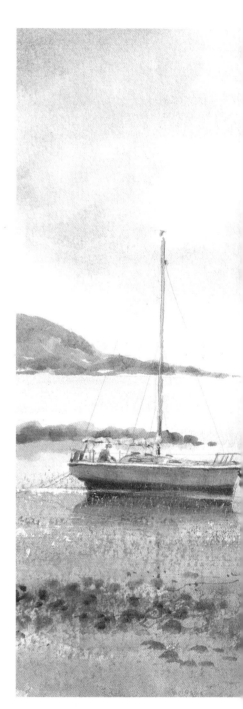

▶ *Eilean Donan Castle*
330 × 530 mm (13½ × 21 in)
This much-painted Scottish landmark makes a striking subject. Originally I painted it from a reference photograph taken on an overcast day, but this version is less heavy and the low vantage point helps the castle to stand out. Note the effective use of dry brush work on the shore. This is Chromacolour used in traditional watercolour style, although a few opaque touches have been introduced here and there.

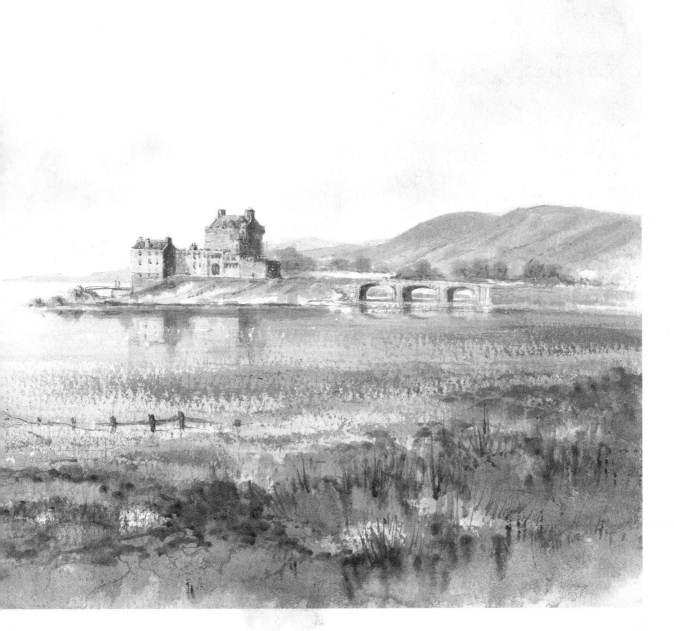

The Chroma Phenomenon

Chromacolour is a water-based paint so powerful that it can be diluted seven times more than traditional watercolours, yet can also be applied in thick opaque layers like gouache or in fine transparent glazes that retain their fresh vitality, layer after layer. It can be used like oil paint, yet dries quickly and does not give off unpleasant odours; it can be easily thinned or thickened and applied by brush or palette knife. Used as an acrylic-style paint, it can be squeezed straight from the tube for impasto effects, yet dries without cracking; or it can be thinned right down to create beautiful transparent washes.

AN INNOVATIVE MEDIUM

Available in 80 vibrant, lightfast colours, Chromacolour dries almost the same colour as when it is applied. This new medium is suitable for a variety of applications on a wide range of surfaces; it is a paint so versatile that in time it could supersede most of the conventional paints currently in use.

When I first became aware of Chromacolour its manufacturers suggested that here was a paint likely to turn the art world upside down. Yet, knowing the average artist's natural reluctance to change from a favoured way of working and with so many established media to choose from, I felt that Chromacolour would need to be very special to create any kind of impact.

Some time later, when I was asked to make a video on Chromacolour, I jumped at the chance to assess the paint myself. At the time I was somewhat dubious about the claims made for it and wondered whether one paint really could be used in such diverse ways. Surely there had to be a catch? Jon Prudence, the man behind the emergence of Chromacolour, suggested that I was not the first artist to question whether the medium was too good to be true: 'A lot of people think we exaggerate when we describe all

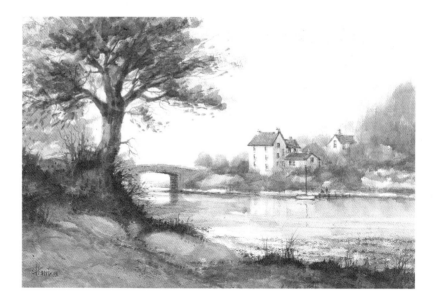

▲ *Bridge Over the River*
312×480 mm ($12\frac{1}{4} \times 19$ in)
A normal watercolour on the surface, but is it? This started life as a watercolour; once rejected, it is now overpainted with Chromacolour. So pull out all those old duds and enjoy making them into new paintings.

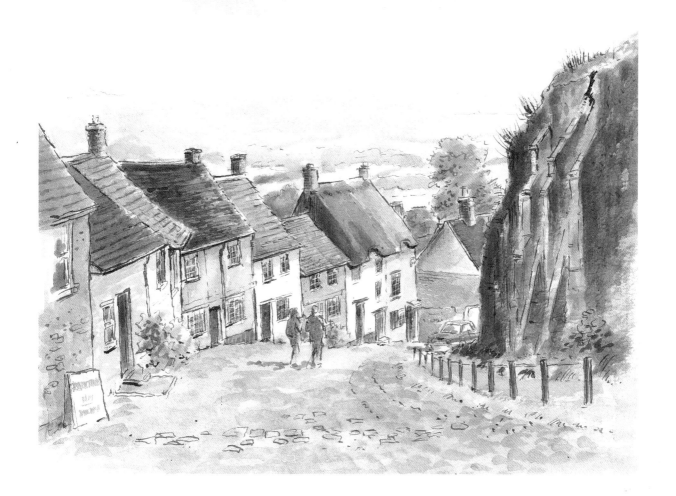

▲ *Gold Hill, Shaftesbury*
255 × 270 mm (10 × 10½ in)
A famous view of a small market
town in Dorset. No marks for
originality, but – here is the
difference – the lines were drawn
in thin black Chromacolour and
then overpainted with
transparent washes.

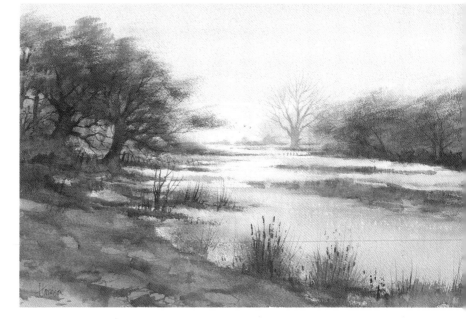

▶ *Autumn River*
295 × 455 mm (11½ × 18 in)
Opaque paint in warm colours –
this is Chromacolour straight from
the tube, with a little water added.

the things that Chromacolour can do, but most of the artists who work with it in a serious way, including some of the world's top professionals, are convinced that this is the biggest breakthrough since the advent of acrylics.'

THE DEVELOPMENT OF CHROMACOLOUR

The paints were developed from the huge range of specialized animation paints that Chromacolour has supplied to the film industry for many years – a range of more than 2000 colours, produced to very exacting standards requiring them to adhere to acetate for a minimum of 50 years without flaking,

cracking or fading. After four years of research, tests and trials, the paints were successfully adapted to suit the requirements of the wider Fine Art market.

Until now artists have had to learn to master the particular problems associated with the medium they are using, with watercolour, gouache, acrylic and oil paints all requiring a different way of working. These difficulties have been resolved with the development of Chromacolour, which allows you to achieve most of the effects of traditional paints more easily, so that you can produce a wide variety of subjects in many different styles. You now have the freedom to express creative ideas in any way you choose!

▼ *Sunset*
450 × 560 mm (17¾ × 22 in)
Where are the sunglasses? Painted on canvas board, this was an exercise to illustrate the strength of Chromacolour and how it can be painted on most surfaces without priming them.

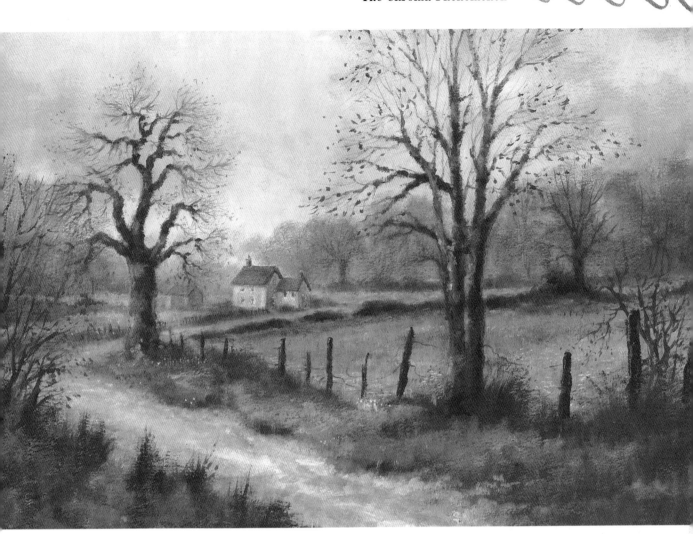

By virtue of its flexibility, Chromacolour blurs the distinction between the different paint media. Art should give pleasure to both painter and viewer, and a medium that offers both amateur and professional artists opportunities to indulge in this enjoyment in more diverse ways is to be commended.

I am grateful for the opportunity to introduce you to Chromacolour — without doubt a new and quite extraordinary medium.

▲ *Autumn Woodland Scene*
330 × 480 mm (13 × 19 in)
This oil-style picture was painted on watercolour paper in Chromacolour. The brush strokes are not obvious, but the techniques employed were typical of those used when painting in oils.

Materials and Equipment

For the benefit of those who are unfamiliar with Chroma Artists Colours, a brief description of the paints and some pointers on their use, as well as the other materials that you may need, may be helpful.

THE PAINTS

Most manufacturers add fillers to make their paints more opaque, but Chromacolour paints have more pigment added instead, resulting in more vibrant colour. Although you are unlikely to need them all, an impressive range of colours is available to suit every requirement, ranging from subtle flesh tones to bold, bright colours. There are 80 colours to choose from, and all of them are lightfast, waterproof and permanent.

Many beginners find the names of colours confusing because paint manufacturers often use their own brand names to denote a particular colour. If in doubt, check out the paint colour before you buy. A full colour chart of Chromacolour paints is available, but because the colours are printed they may not match the real paint colours precisely.

POTS OR TUBES?

Chromacolour is supplied in pots and tubes that keep the paint fresh and usable, provided you replace the tops when not in use. The only difference in the contents is that the consistency of the paint in the tubes is slightly thicker, so your choice is likely to be dependent on subject matter and personal preference.

The pots should be shaken before use and tapped gently on your hand or a table top to clear the paint from the little spigot in the lid that is there to keep the paint from drying out. Watercolourists may well prefer the runny nature of the pot paint because it is easy to dilute, while the consistency straight from the pot will also suit painters in opaque style because it is ideal for applying broad flat areas of colour for underpainting.

The thicker consistency of the tube paint offers many advantages. It can still be diluted instantly to produce fine transparent washes, but straight from the tube it can be used in a similar way to gouache or acrylic with the advantage of working from light to dark or dark to light.

Whether from pots or tubes, when used neat, the paint is opaque and dries to a smooth, matt, waterproof finish. The colours can be lightened by

◀ A selection of Chromacolour pots and tubes.

80 VIBRANT ARTISTS COLOURS

101 LINDEN — Series 3	121 ALIZARINE CRIMSON HUE — Series 2	141 BRILLIANT BLUE — Series 2
102 LEMON YELLOW — Series 2	122 CADMIUM RED DEEP HUE — Series 3	142 TURQUOISE BLUE — Series 2
103 CADMIUM YELLOW LIGHT HUE — Series 3	123 DEEP BRILLIANT RED — Series 2	143 TURQUOISE GREEN — Series 2
104 YELLOW MEDIUM AZO — Series 2	124 ROSE — Series 2	144 SEA GREEN — Series 2

101 LINDEN Series 3
102 LEMON YELLOW Series 2
103 CADMIUM YELLOW LIGHT HUE Series 3
104 YELLOW MEDIUM AZO Series 2
105 CADMIUM YELLOW MED HUE Series 3
106 CHROMA YELLOW Series 2
107 CADMIUM YELLOW DEEP HUE Series 3
108 NAPLES YELLOW Series 3
109 GAMBOGE NEW Series 2
110 CADMIUM ORANGE HUE Series 3
111 CHROMA ORANGE LIGHT Series 2
112 CHROMA ORANGE Series 2
113 CHROMA ORANGE DEEP Series 2
114 CADMIUM RED LIGHT HUE Series 3
115 SCARLET Series 2
116 CADMIUM RED MEDIUM HUE Series 3
117 VERMILION HUE Series 2
118 CHROMA RED Series 2
119 CHROMA RED DEEP Series 2
120 NAPHTHOL CRIMSON Series 2

121 ALIZARINE CRIMSON HUE Series 2
122 CADMIUM RED DEEP HUE Series 3
123 DEEP BRILLIANT RED Series 2
124 ROSE Series 2
125 MAGENTA LIGHT Series 3
126 MAGENTA MEDIUM Series 3
127 MAGENTA DEEP Series 3
128 MAROON Series 3
129 BRILLIANT PURPLE Series 3
130 PRISM VIOLET Series 3
131 CHROMA VIOLET Series 3
132 DIOXAZINE PURPLE* Series 3
133 INDIGO* Series 2
134 PRUSSIAN BLUE Series 2
135 PHTHALO BLUE Series 2
136 ULTRAMARINE Series 1
137 COBALT BLUE HUE Series 3
138 CHROMA BLUE Series 2
139 CERULEAN BLUE HUE Series 3
140 MANGANESE BLUE HUE Series 3

141 BRILLIANT BLUE Series 2
142 TURQUOISE BLUE Series 2
143 TURQUOISE GREEN Series 2
144 SEA GREEN Series 2
145 PHTHALO GREEN Series 2
146 VIRIDIAN HUE Series 2
147 HOOKERS GREEN HUE* Series 2
148 PERMANENT GREEN DEEP Series 2
149 SAP GREEN Series 2
150 CHROMIUM GREEN OXIDE Series 3
151 LIGHT GREEN OXIDE Series 3
152 EMERALD GREEN Series 2
153 PERMANENT GREEN LIGHT Series 2
154 CHROMA GREEN Series 2
155 LIME GREEN Series 2
156 CHARTREUSE Series 2
157 OLIVE GREEN* Series 1
158 OLIVE GREEN LIGHT Series 2
159 YELLOW OCHRE Series 1
160 RAW SIENNA Series 1

161 BURNT UMBER Series 1
162 VANDYKE BROWN HUE* Series 2
163 SEPIA* Series 2
164 RAW UMBER Series 1
165 VENETIAN RED HUE Series 2
166 RED IRON OXIDE Series 1
167 BURNT SIENNA Series 1
168 PORTRAIT Series 1
169 FLESH Series 1
170 FLESH PINK Series 1
171 WARM GREY Series 1
172 COOL GREY Series 1
173 PAYNES GRAY * Series 1
174 MARS BLACK Series 1
175 IVORY BLACK Series 1
176 CHROMA BLACK Series 1
177 UNBLEACHED TITANIUM Series 1
178 PARCHMENT
179 TITANIUM WHITE Series 1
180 CHROMA WHITE Series 1

Whilst the most sophisticated colour scanner is used, some allowance will be required for minor variations in calibre brought about by the printing process. Colours marked * will have been lightened to allow a better representation of the colour to show through.

▲ The full range of
Chromacolour paints.

diluting with water for transparency or by adding white paint to achieve lighter tones while retaining opacity. Always make sure, however, that you add colour to the white and not the other way round, as it takes a great deal of white paint to tone down a dark colour.

MEDIUMS

A range of special mediums are available that you can add to change the consistency of Chromacolour paint so that, as with acrylic and oil paints, you can achieve different textures.

SURFACES AND SUPPORTS

A variety of supports – the surfaces on which you paint – can be used, including paper, card, canvas board, stretched canvas, plywood, Masonite, or hardboard. In fact, Chromacolour

paint can be used on almost any surface without any priming, because the underwash itself acts as a sealer; it can also be used as a base for pastels if required. If you prefer a gesso-primed surface to work on, however, a water-based one is available from Chromacolour. For detailed work, especially for painting in opaque style or for line work, smooth art boards are pleasant to work on. Choose a hot-pressed surface, which is the smoothest grade. For transparent work, watercolour paper is ideal and is available in hot pressed (smooth), not pressed (medium textured) and rough (which has a heavier textured surface). If you buy this in weights of 420 gsm (200 lb) or 638 gsm (300 lb), it will not require stretching; this is my own preferred choice and I just clip it onto my painting board at the corners. If you find the thicker papers too expensive, by all means use 190 gsm (90 lb) and 300 gsm (140 lb), which are

the other common weights, but these papers are best stretched before use, otherwise they may cockle when wet and spoil your painting. To stretch the paper soak it for a minute or two in the bath, let the water drain off, then attach it to a suitable flat wooden board with brown gummed parcel tape on each edge, overlapping the paper by about 25 mm (1 in). Do not tape thin watercolour paper all round the edge like this if it has not been soaked in water, otherwise it will buckle like a corrugated roof when damped.

PALETTES

The speed of drying of Chromacolour is an advantage to artists who work quickly, but if you tend to paint more slowly, especially if you are a beginner, you may find a stay-wet palette helpful to accommodate your squeezed-out paint and prevent it drying out too quickly. I use one myself and the paint keeps moist, even when left for two or three weeks or more, provided the lid is carefully sealed. To make the lid easier to fit and remove, wipe around the top of the tray with a little petroleum jelly. When you remove the lid, start with the four corners and you will then find the sides easier to lift.

When using Chromacolour in watercolour or gouache style, I use a stay-wet palette in conjunction with a china dinner plate on which I actually mix the

◄ Some of the many different surfaces and supports on which Chromacolour can be used.

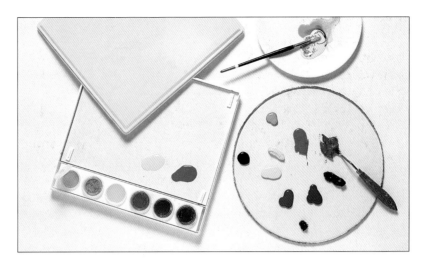

colours. Avoid using a plastic palette because the paint will adhere to it once it has dried. Using a china plate, even paint that has been allowed to dry hard can still be removed with warm water or scraped off with a palette knife.

When painting in opaque style, a thick piece of glass with the edges buffed for safety and then taped over, provides an ideal flat surface for mixing. Mounting a piece of white card underneath the glass allows you to see the colours more clearly. I also find the glass comes in useful to place over the china plate to keep the paint fresh during a temporary break in proceedings.

BRUSHES

No special brushes are needed when you paint with Chromacolour. Simply use your normal sable, synthetic or bristle brushes, but with one proviso – ensure you wash them out regularly. I use the same brushes that I have used for watercolours over the years and they are still giving good service.

My own selection includes a 50 mm (2 in) hake (goat hair) brush – always buy ones that have a slot down the side and are stitched in preference to ones with metal ferrules; they seem to hold their shape better. I also use a 25 mm (1 in) flat brush; this does not need to be of particularly good quality as long as it holds its shape and forms a chisel edge when stroked backwards and forwards on the palette. The round sable brushes I have are a size 7 and a size 14 (this is expensive, so you may prefer a sable substitute). I use

my favourite brush – a long-haired rigger size 1 or 0 – for painting fine lines.

For opaque work, you will also need some bristle brushes – mine are an 18 mm (¾ in) flat, a size 8 round and sizes 4 and 7 filberts (the ones with the rounded corners).

If you should neglect your brushes, all is not lost; Chromacolour have developed a really effective non-toxic brush cleaner and conditioner that allows you to soak away wet and even dried-on paint from both natural and synthetic brushes. It is gentle on the fibres and much safer than using solvents. After using the brush cleaner, you wash the brushes with conditioner and apply size to restore the brush to its original shape. This treatment revitalizes tired or damaged bristles. Painters who work in other media will also find that it is just as effective for brushes used with traditional oils and acrylics.

Other useful accoutrements are a natural sponge for foliage work (if you do not enjoy using the hake); painting knives for impasto work (to which I will refer again later); and an old credit card or a scalpel for scraping out highlights.

▲ A stay-wet palette prevents paint drying out too quickly, while a china dinner plate and a glass palette are ideal for mixing colours.

▼ A selection of painting tools, including sable, flat and bristle brushes, a painting knife, dip pen, scalpel and natural sponge.

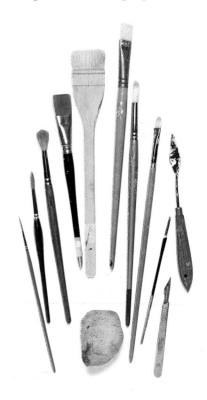

Mixing Colours

With such a dazzling range of colours available you are spoilt for choice, so I suggest using a limited palette to start with, then adding further colours later to suit your subject matter. Much is written about the merits of using a limited palette and how the great masters often used only four or five colours, but it is far better to make your wider selection based on logic and personal preference.

WARM AND COOL COLOURS – THE ESSENTIAL CHOICE

It is important to start off with a sensible selection of colours that offer you flexibility in colour mixing. For me, this means including a warm and cool version of each of the three primary colours of yellow, red and blue – the three colours that cannot be mixed by blending other colours together – plus a few 'useful' extra colours. This gives you an economical starter set that allows plenty of scope for mixing further colours without costing you a fortune.

We think of cool colours as those that present a cool appearance – for example, some blues, greens and the greenish-looking yellows; and warm colours as those that convey warmth – for example, oranges, reds, orange-yellows and browns.

THE STARTER PALETTE

A typical Chromacolour starter palette might consist of three cool primary colours such as Lemon Yellow, Alizarine Crimson and, say, Cobalt Blue, which is really a mid-tone blue (a pleasant cool alternative is Cerulean Blue); plus three warm ones such as Cadmium Yellow Medium (or Chroma Yellow, which is similar but stronger), Cadmium Red Medium and Ultramarine. The

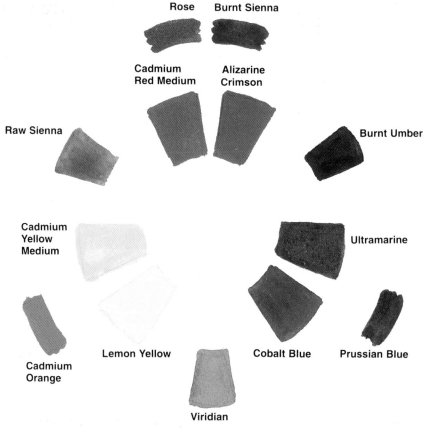

Rose Burnt Sienna
Cadmium Red Medium Alizarine Crimson
Raw Sienna Burnt Umber
Cadmium Yellow Medium Ultramarine
Lemon Yellow Cobalt Blue Prussian Blue
Cadmium Orange Viridian

▲ Choosing a warm and cool version of each of the primaries allows great flexibility in colour mixing. Additional colours can be added to suit particular subjects or your own preferences.

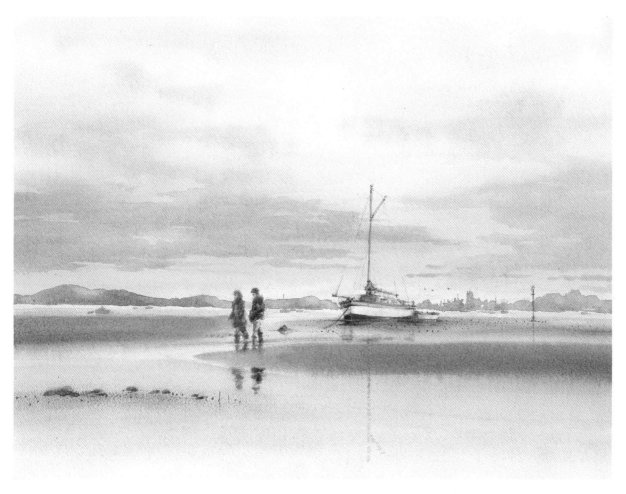

choice of primaries is very much a personal one and you may prefer to select a completely different range of colours, but try to keep to the general principle of one cool and one warm version of each of the three primaries to form the basis of your palette.

OTHER USEFUL COLOURS

For the additional colours, I would suggest Raw Sienna (or Yellow Ochre), which will give a warm glow to your underpainting and will also mix with blue to give a useful range of greens; and Burnt Umber, a warm deep brown, which, when mixed with blue, will give you pleasant greys as well as strong dark tones

close to black. Some artists prefer Burnt Sienna, which also makes strong darks when mixed with blue. Cadmium Orange and Rose are colours likely to appeal to flower painters and for a more powerful blue I would choose Prussian Blue. In selecting colours we are fortunate not to have to worry about whether they are fugitive or not because all Chromacolour paints are permanent and do not fade.

For painting in opaque style you will need white (Titanium White is recommended for mixing, Chroma White is useful as an opaque white paint). If you prefer ready-bought greens to mixing your own, there is a wide choice. I usually like to mix my own greens, but I do sometimes use Viridian because, although it

▲ *Low Tide*
330×510 mm (13×20 in)
Here Chromacolour is used in a restrained way to create a quiet mood. The subtle tones are mostly obtained from just three colours – Raw Sienna, Cadmium Red Medium and Cobalt Blue. After painting the early washes wet-in-wet, I allowed each layer to dry out in the latter stages. The low viewpoint gives more impact to the painting.

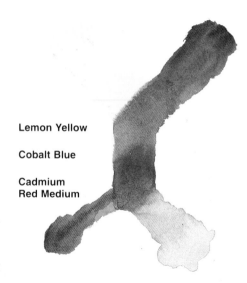

Lemon Yellow

Cobalt Blue

Cadmium
Red Medium

is a powerful, rather strident staining colour, it can be mixed with other colours to produce more subtle shades of green or diluted or mixed with blue to suggest the distant sea in coastal scenes.

I rarely use Black because you seldom see a true black in real life and it is easy to mix a dark colour that comes close but is more interesting; for example, Burnt Umber or Burnt Sienna mixed with a dark blue such as Ultramarine.

HARNESSING THE POWER OF CHROMACOLOUR

When you first use Chromacolour paints you will be surprised at the amazing brightness of the colours and this vibrancy can be used to great advantage. If, like me, you prefer to use subtle shades of colour and muted tones in your paintings, you will need to neutralize the colours slightly – not excessively so that their clarity is destroyed – but in a controlled manner.

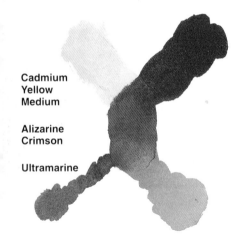

Cadmium
Yellow
Medium

Alizarine
Crimson

Ultramarine

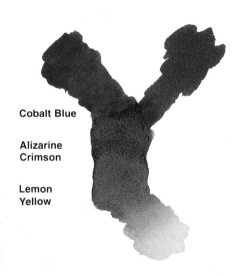

Cobalt Blue

Alizarine
Crimson

Lemon
Yellow

◀ *Neutralizing colours*
Adding a touch of the complementary colour helps to neutralize or tone down any colour. An easy way to remember this is – mix any two primary colours and the third primary colour is the complementary, so that is the one to add.

PRIMARY BLENDS FOR SUBTLE HUES

Subtle hues are simple to achieve, following established principles of colour theory. To see how this works, take two primary colours and mix them together; for example, Lemon Yellow and a small amount of Cobalt Blue. The resulting green may be too strong and not to your liking, but you can take the brightness down by adding just a touch of the complementary colour, which is the other primary – in this case, Cadmium Red. Adding just a small amount of this will produce a more neutral green. If you add too much and the mixture is too red, simply add a little more of the two primary colours you started with until you achieve the exact hue you want. This is a standard painting technique that can be used throughout the range of colours.

You can achieve a similar result by adding blue to an orange mixture (produced from red plus yellow) and yellow to a violet mixture (produced from red plus blue). For a paler colour, simply add a little more water (or white if you are working in opaque style).

WARMING OR COOLING COLOURS

You can adjust your colours in other ways, too. If you are working on a winter scene, for instance, you may wish to cool your colours. This can be done by mixing them with another colour that has a leaning towards blue or, of course, with blue itself. For a summer or autumnal scene that requires a sunnier look, you

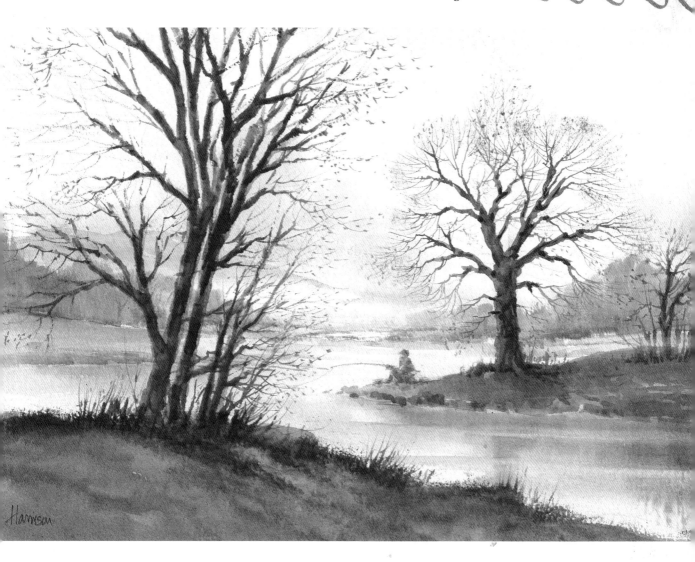

can give more warmth to your colours by adding a little warm red or a colour that has a leaning towards red.

ACHIEVING THE RIGHT BLEND

Whenever you are mixing Chromacolour paints, rather than adding a little paint to a great deal of water, it is best to dilute a small amount of paint with water first and then gradually add more paint or water to produce the colour you want. In this way you are unlikely to end up with a large quantity of diluted colour for which you need to find a home, a common problem for newcomers to painting. Chromacolour is powerful and needs to be diluted more than you may be used to with other paints, but it pays to be sparing with the water on your palette and utilize the dampness retained in your paper surface to good effect.

▲ *The Solitary Fisherman*
312 × 480 mm (12¼ × 19 in)
The warm tones of late autumn are achieved by adding a touch of red – in this case, Alizarine Crimson and Cadmium Red Medium – to the yellows and browns in the trees and fields.

Using Chromacolour

Chromacolour is such a versatile medium that you can choose to use it in many different ways according to your own preference. While it is now recognized as a new medium in its own right, it is interesting to see how Chromacolour compares with the traditional media when used to paint using methods associated with those media. So in this section I suggest art techniques with which you will be familiar, to give you the chance to compare its qualities. One point to bear in mind is that if you are already using water-based paints such as watercolour, gouache or acrylics, Chromacolour will work side by side with them so you do not have to throw away your stock of paints before you can try Chromacolour.

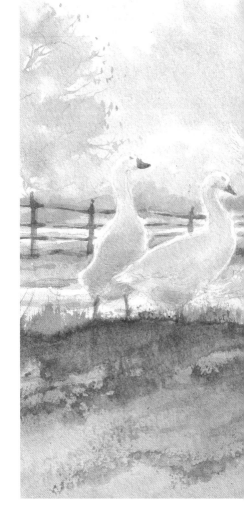

▶ *Geese*
290 × 480 mm (11⅜ × 19 in)
**Geese make delightful subjects.
Transparent techniques were used
here to show the sun shining
through the flapping wings.
Backlighting creates bright edges
to the feathers and these were
emphasized with a touch of
Chroma White in places.**

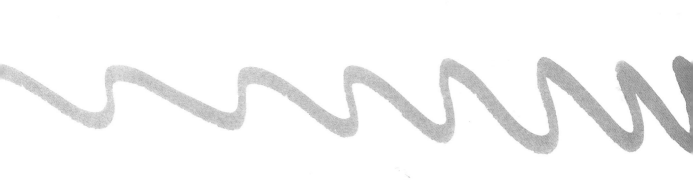

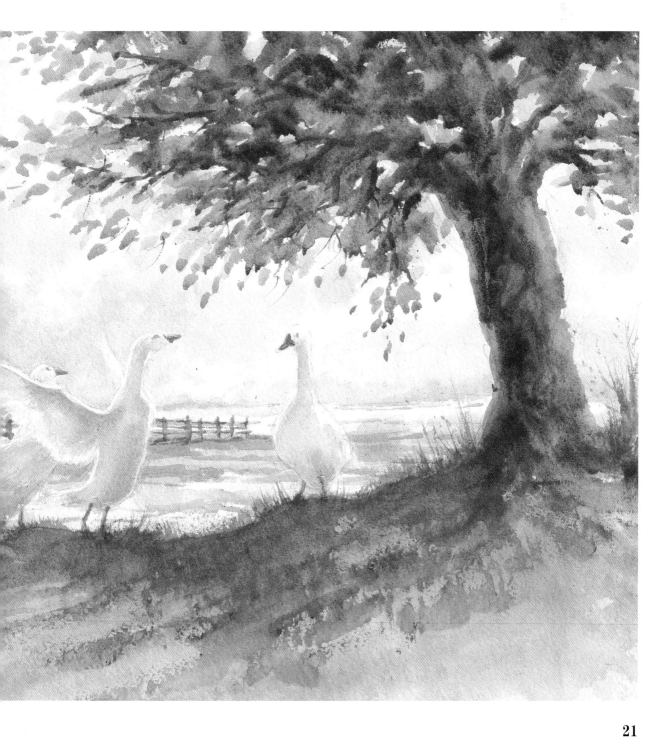

In the Style of Transparent Watercolour

From a watercolourist's perspective, the big advantage of using Chromacolour paint is that it dries the same colour as when it is wet – in computer jargon, what you see is what you get. This is obviously a great help in creating contrasting tonal areas, particularly the pale washes that are necessary to indicate distant hills, mountains and fields. Once you find the right tone it is comforting to know that the paint will look the same when dry.

There are two other important differences: the colours are lightfast so you do not need to hide your masterpieces away in dark places to stop them fading; and the paints are waterproof when dry, so when you lay a wash onto dry paint the layer below is not disturbed or spoiled.

TAKE MORE WATER WITH IT

Chromacolour paints contain a lot of pigment. A wash painted with artists' quality watercolour paint diluted 100 times looks very similar in tone to a wash painted with Chromacolour diluted 700 times, which suggests that Chromacolour is around seven times stronger.

So when you first paint with Chromacolour and pick up your usual amount of paint from the palette and dip the brush in a little water, the sheer intensity of the colour comes as quite a shock. You soon realize that compared to conventional artists' watercolours, you need less paint and a little more water to produce the same strength of colour.

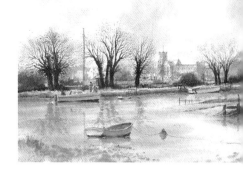

▲ *Christchurch Priory and River, Dorset*
325×480 mm ($12\frac{3}{4} \times 19$ in)
A popular local view that looks more interesting in spring and autumn as the leafless trees allow the ancient priory to be seen more easily. I used transparent techniques throughout. Highlights on the water are done with the gentle use of glasspaper.

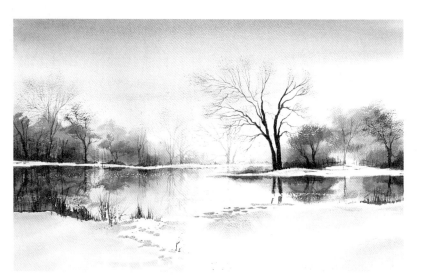

◄ *Reflections of Winter*
330×480 mm (13×19 in)
The white of the paper is effectively used to suggest the snow. This was only my second painting in Chromacolour and I found the range of subtle winter tones easy to reproduce.

▶ *Graduated wash*
After loading the brush with a fairly strong mixture of colour – I have used Raw Sienna here – pull it horizontally across the paper, taking each brush stroke through the bottom of the one above so that the bands of colour blend together. This is standard watercolour practice. As you work down the paper, add clean water to progressively lighten the colour until the colour gently fades away.

QUICKER DRYING MEANS FASTER WORKING

Chromacolour paints dry fairly quickly compared to watercolours (but slower than acrylics), so you are able to work more quickly without resorting to using the hair dryer on your paintings. If you are one of those artists who paints very slowly and find the paint dries a little too quickly for you, a few drops of Chroma Retarder added to the paint or the water will slow down the drying time. Personally, I have never found the need for it when working in watercolour style.

When painting with Chromacolour, I would remind you to wash your brushes a little more frequently. I always use two jars of water (or preferably, small plastic buckets) – one for rinsing the dirty brush and the other for clean water to apply the next colour. I am always amazed at painters who try to make do with one pot of water and then complain that their colours are becoming muddy.

GRADUATED WASH

A good way to ease yourself into using Chromacolour is to practise a simple graduated wash to see how the paint behaves when appplied in a thin transparent layer.

This is a simple wash, applied with horizontal brush strokes. The wash is gradually lightened with clean water as you work down the paper to form a graduated effect from dark at the top to light at the bottom. This technique is useful to give the impression of a typical cloudless sky.

The method is one that is commonly used in traditional watercolour or gouache painting and the result is much the same. The big difference is that when you use Chromacolour the colour does not change as it dries – the surface shine merely changes to a matt finish. This is a great help to beginners and, once dry, the layer of colour will be waterproof and will not wash off. So if you are happy with your wash, let it dry and it will stay just as you painted it. If you are not happy with your work, correct it while the paint is still wet.

WET-ON-DRY

Once a layer of paint is dry another wash can be applied without disturbing the layer below. To illustrate this for yourself, apply a second wash on top of the first to make it bolder. Should you make a mistake during this overpainting the new layer can be washed off before it dries without spoiling your earlier painting.

▲ *Wet-on-dry*
Having allowed the first layer of paint to dry out, use a strong mixture of a second colour – here it is Cobalt Blue – and overpaint another graduated wash, again working from dark to light, diluting the paint with clean water as you progress down the paper.

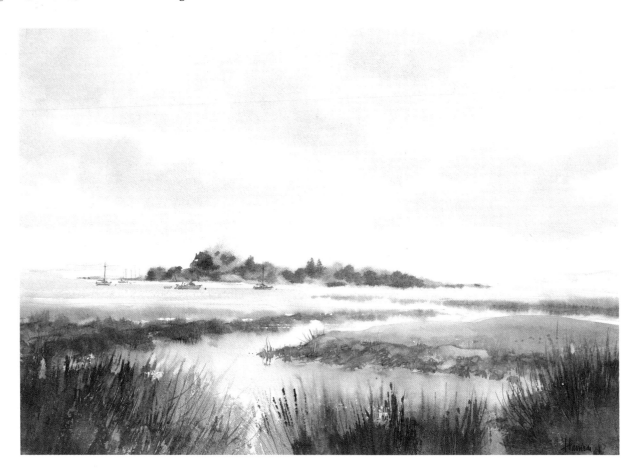

▲ Shipstal Point, Poole Harbour
330 × 510 mm (13 × 20 in)
Wet-in-wet techniques were used throughout this painting after the initial underwash of Raw Sienna was allowed to dry. A 25 mm (1 in) flat brush was used except in the foreground, where the spiky grasses were pulled out with a rigger and the discreet use of the edge of an old credit card.

▲ Wet-in-wet
Take a little of the Cobalt Blue paint to one side and add more paint, plus a tiny amount of Cadmium Red Medium to give a stronger colour; do not add more water (because the water is already on the paper surface). Then pull a horizontal streak of paint across the paper. If your timing is right this will spread a little with a pleasant soft edge. This is a useful method of painting a winter sky.

WET-IN-WET

If you want to add a dark streak across the lower part of the sky in your painting then a good opportunity to add one is before the second wash dries out. Use a wet-in-wet technique for this (for new painters this means adding fresh paint to a previously painted area while it is still damp, to give a soft-edged effect).

Before trying this, I look at the surface of the painted area from the side to check the dampness. It is important to wait for the glossy shine to give way to a matt sheen, because if you add paint too soon while the surface is still very wet and shiny, the paint will be hard to control.

Wet-in wet is also a useful technique for painting trees. Many beginners have problems with trees because they fail to

achieve the correct proportions. To paint winter trees my approach is to draw the shape very simply and paint the trunk and main branches with a medium-size round brush, then use a rigger to indicate the thinner branches and small twigs. The branches should become progressively narrower. Problems usually arise from making the branches too thin too quickly, resulting in a tree that resembles a chimney sweep's brush.

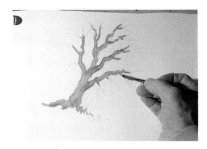

▲ Wet-in-wet for winter tree and branches
This simple wet-in-wet practice exercise should help your tree painting. Try various different tree shapes using the same procedure. Using a mixture of Raw Sienna with a touch of Ultramarine and Cadmium Red Medium, paint the trunk at a slight angle, then pull out the main branches with an upward zigzag movement.

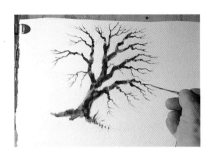

▲ As this dries out, add a darker mixture of colour in places to give more shape to the structure. Notice that the branches are not curved like a fountain of water.

STARTING A PAINTING WET-IN-WET

Although summer skies are often cloudless and can be painted as a graduated wash, to produce a more interesting sky try a wet-in-wet technique. In this case it is helpful to start by damping the paper all over with clean water; this makes it easier to produce soft edges to the clouds.

When painting wet-in-wet, timing is crucial if you are to avoid unplanned and irritating backruns or cauliflower patterns that sometimes occur as the result of poor technique or excessive use of water and which, I believe, spoil the look of a painting. Chromacolour seems to be more forgiving than watercolour in this respect and you can take more liberties with the timing. If a river or the sea are included in your scene, paint this at the same time as the sky so that the reflected colour matches.

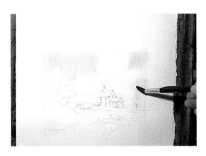

▲ Wet-in-wet for summer skies
Soft-edged clouds can be suggested by leaving areas of the paper unpainted (previously dampened) and painting round them with Cobalt Blue, using an up and down motion with a medium size round brush.

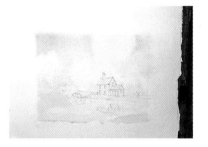

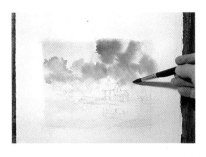

▲ Underpainting wet-in-wet
Here pale Raw Sienna is touched in on the clouds, buildings and the river banks.

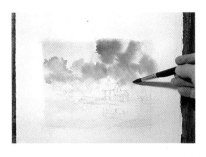

▲ Combining wet-in-wet and wet-on-dry
The stronger cloud shapes are painted using a mixture of Ultramarine and a small amount of Raw Sienna and Cadmium Red Medium, working into the still damp paper. Where the colour overlaps onto the drier blue sky, crisper dry edges are produced, so make these irregular to achieve a natural look. It is important to vary the colour strength and leave gaps in the cloud masses when working wet-in-wet, otherwise the colours run together forming huge flat uninteresting blotches.

OVERPAINTING TO GIVE FORM

When painting structures like buildings, rather than paint each wall and the roof separately, paint the whole building to start with, then apply layers of colour, allowing each layer to dry in between. If each time you overpaint you leave one wall unpainted, the varied tones of the walls will suggest form and depth. It is a good idea to paint the underwash for other areas such as the river bank and reflections in the water at the same time as you paint the building.

The first layer can be a light wash of Raw Sienna, which is allowed to dry. Then more layers of slightly darker colour can be overpainted, each time leaving some of the previous layer unpainted to create variations in tone to give a three-dimensional effect. Paint all the layers loosely, or the painting will look too precise. The quick-drying nature of Chromacolour lends itself well to this way of painting; because of the purity of colour, even multiple layers do not acquire the muddy look that is common to traditional watercolour.

Bridges need to be treated loosely and there is no need to paint every stone. It is essential to make the shape of the arch correct and in particular the reflection below. I tend to think of the shape as similar to the top half of a pair of glasses, with the reflection completing the image.

A quick stroke of pale blue-grey indicates the windows and door and when dry, a darker touch of the same colour on the lower part of the windows and a thin line above and to one side gives more life to the building.

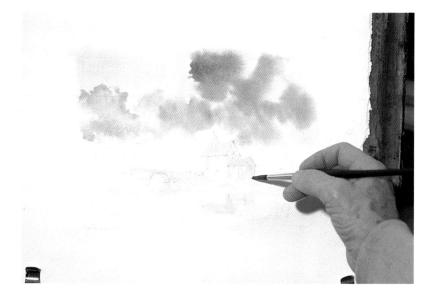

▲ *Overpainting*
When the Raw Sienna underwash painted while working on the sky is dry, a second layer is added, darkened this time with a little Cadmium Red Medium and Ultramarine. The reflections in the river are painted at the same time.

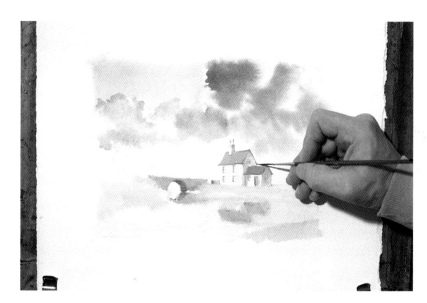

▲ *Final overpainting*
The third layer brings out the shape of the building. Using a slightly stronger mixture, the edge of the roof and shadows around the windows are painted. The windows will be added later, using a pale wash of Cobalt Blue to reflect the sky, and the shadow side of the building can be emphasized with a pale wash of blue-violet.

DEFINING EDGES
WET-ON-DRY

When painting trees around buildings it is better to paint wet-on-dry to start with, so that the dark outline of the trees creates a clear edge to the buildings. The colour can be strengthened in places with darker colour applied wet-in-wet. This makes the most of dark against light contrast to good effect.

CREATING DISTANCE

The foliage of both distant and nearer trees can be painted using various pale tones mixed from Cobalt Blue and Raw Sienna. Allow the light colours to soak in, and just before they dry out use stronger colours to add more body. (Remember not to make the distant trees too dark.) A drier, stronger mixture of paint is always used for the second and succeeding layers when working wet-in-wet because the paper surface contains sufficient dampness without adding to it with a sloppy mixture of paint. For the more prominent nearby trees, the shapes are more clearly defined with the application of heavier colour, but still using the same system of building up layers to give shape and form.

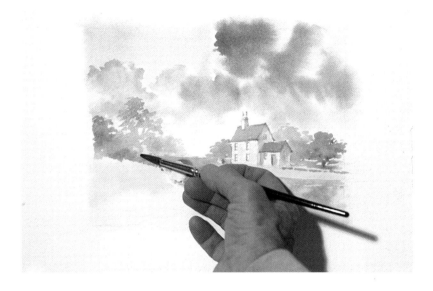

▲ Distant trees
For distant trees, a pleasant range of greens can be achieved using only Cobalt Blue, Raw Sienna and a touch of Cadmium Red Medium. To emphasize an individual tree, stronger colour is used to establish the general shape, leaving gaps for the branches, and then darker shading is added just before the first layer dries out.

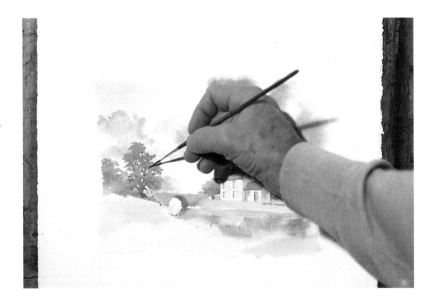

▲ Using a rigger
While the foliage dries out, the trunk is painted, then the branches in the gaps, using the rigger.

DRY BRUSH

If you are not familiar with this term, it means dragging a dry mixture of paint across the paper with the brush flat to the paper to give a speckled, textured effect. You will need to rub the bristles backwards and forwards across a spare piece of paper until most of the paint has been exhausted, otherwise the effect will be too dark. This is a useful technique for indicating sparse foliage or for any other textured effect.

RENOVATING REJECT WATERCOLOURS

If you paint in watercolour, you may have a number of unfinished or reject works or practice paintings. Instead of discarding these, why not overpaint them using Chromacolour? This not only gives them a new lease of life, but also enables you to retrieve paintings that seemed to be beyond recovery with only traditional watercolour at your disposal.

Before you start your overlay, use clean water and gentle persuasion with a bristle brush to lift out paint to lighten any areas that have been applied too heavily. Alternatively, these areas can be overpainted in opaque style later.

My normal method is to quickly, but carefully, damp the paper all over with a large brush and allow the moisture to soak in. Then I gently overpaint with Chromacolour, taking care not to disturb the layer of watercolour paint below. Of course, once you have your first new layer of Chromacolour in place and it has dried out, it will be waterproof, so

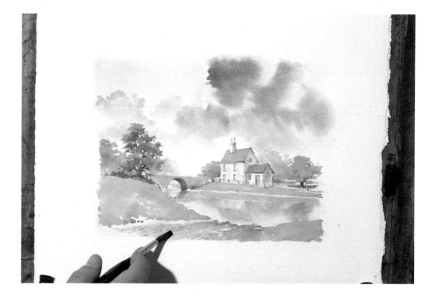

▲ *Dry brush for texture*
Dry brush technique is used to indicate the textured surface of the track by the river. The brush strokes should always follow the natural direction of travel and not be overworked.

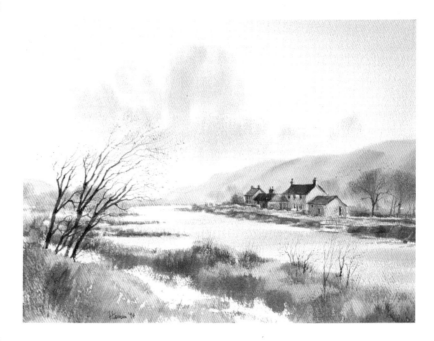

you can then continue as if it were a normal Chromacolour painting. Any areas that are too light can be strengthened at this stage and any that are too dark can be lightened with slightly opaque Chromacolour.

A finished painting in Chromacolour paint or overlaid with Chromacolour is hard to

▲ This placid scene needed something to bring it to life. The foreground and bush were rather insipid to look at.

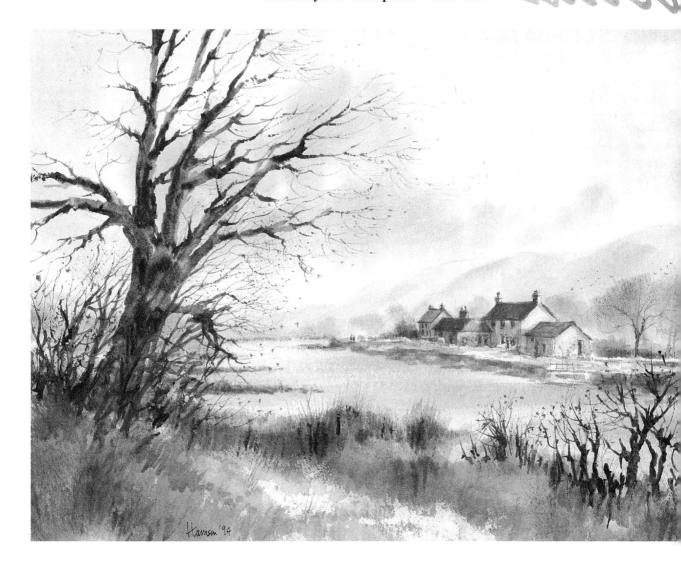

▲ *River Walk*
335 x 455 mm (13¼ x 18 in)
Using Chromacolour, I decided to overpaint a large tree, spruce up the foreground to create a riverside track and insert a twiggy bush on the right for better balance.

distinguish from one painted entirely with traditional watercolour (apart from damping your finger and running it over the surface to see if it is waterproof, which may prove unpopular if the painting is not yours). At exhibitions and workshops I have arranged watercolour paintings, paintings started with watercolour and overlaid with Chromacolour, and paintings using only Chromacolour, side by side for easy comparison. It is virtually impossible to detect the difference between any of them, although the Chromacolour paintings tend to have more vibrancy, which makes them stand out well.

LINE AND WASH TECHNIQUES

Beginners often find it easier to produce a watercolour-style painting by drawing the subject in pencil, inking in the outlines and overlaying pale washes or glazes to create what is known as a line and wash painting. Indian ink is normally used for the outlines because it is waterproof and will not bleed when the washes are applied on top.

Using Chromacolour, only one medium is necessary, as you can dilute one of the dark colours to produce a thin waterproof ink to draw in the outlines. Chroma Flow Improver can be added if you wish, although I find that just adding water is usually sufficient. In general, use thin lines in the distance and thicker lines for the closer subjects. Lines need not be done precisely – in fact, ragged lines of varying thickness give a work great character.

Dip pen or brush can be used as well as a variety of other implements such as matchsticks, cocktail sticks, quills etc. Because Chromacolour dries quickly, colour washes can be applied without delay, but it is best to rub out the pencil guidelines first. This treatment is more effective if the overlaid washes are fairly pale, unless you are one of those flamboyant painters who uses bold lines and loose washes.

WASH AND LINE

Another way of utilizing this technique is to reverse the application of line and wash – in other words, apply the washes first, then make the subject stand out by painting in the ink outline.

▲ *Pencil drawing for Wareham Quay, Dorset*
The pencil drawing is fairly accurate as this is to be a reasonable likeness. For looser work, keep the initial drawing much freer than this.

▲ *Wareham Quay – painting in progress*
A fresh summer look is the intention and the choice of colours reflects this.

This can be done precisely using a dip pen or fine brush for an accurate rendition or, loosely, with a larger brush for a more spontaneous effect.

My view of Wareham Quay is painted using this method and is also painted as a vignette. To do this successfully it is important to leave a good area of white (or light) space around the subject. Connections need to be made, or suggested, to all four sides of the border and this works best if each side of the frame is touched by a variable amount.

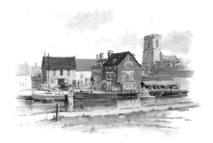

▲ *Wareham Quay – colour work complete*
Having finished the colour work, you can start lining in. Leave the edges fairly loose in order to achieve a vignette effect. The strong horizontal lines formed by the quay, river and path are offset by the vertical lines of the mast and the figure in the foreground, which is intended to balance the other vertical feature – the church tower in the background.

▲ *Wareham Quay – dip pen in use*
Try to keep the lines fairly ragged to avoid the work looking too precise. You may find a rigger helpful to paint some of the lines.

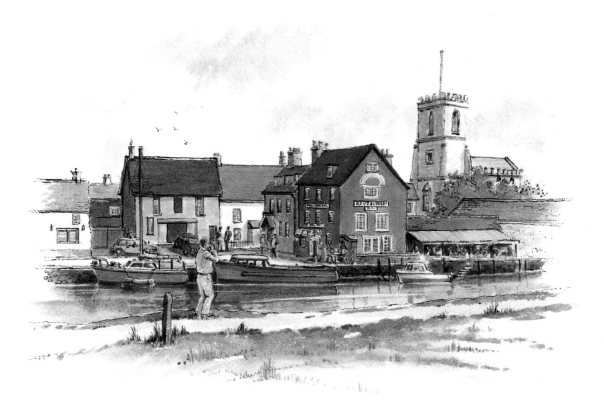

▲ *Wareham Quay, Dorset*
205 × 305 mm (8 × 12 in)
The ideal subject and the perfect spot for afternoon tea. The underwash seals the pencil drawing when dry – a useful feature of Chromacolour. The washes were applied first, then the black linework on top. Try it in sepia, for a Victorian look.

LINE DRAWINGS

You may prefer to depict your subject purely in terms of line, in which case you can choose from any of the Chromacolour range of colours, dilute the paint and use it like ink. This drawing of St Mary's Church is a typical example drawn with a dip pen, with extra emphasis added with the brush.

◄ *St Mary's Church, Lytchett Matravers, Dorset*
255 × 255 mm (10 × 10 in)
A quick line drawing of the local church for my friends who ring the bells. Diluted Chromacolour works well as an ink, and you have a choice of 80 colours.

In the Style of Gouache

Artists have painted in opaque style since the Middle Ages using gouache or body colour, but it has never achieved the same popular appeal as watercolour because, unfortunately, it has a number of limitations. It changes colour as it dries, with light colours becoming darker and dark colours lighter, and if the paint is applied too thickly, cracking of the surface can occur. When one coat is overlaid on another, the new layer of paint can soak in and stir up the previous one, causing unsightly patches, and also the surface marks easily when it is dry.

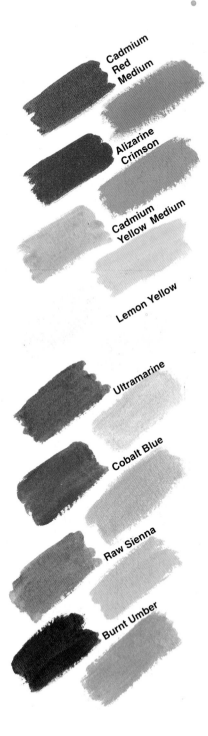

OPAQUE ADVANTAGES

By comparison, Chromacolour paint straight from the tube is opaque, covers extremely well and dries virtually the same colour. Because it is waterproof when dry, overpainting is no problem and the layer below is not disturbed, which allows you to continue overpainting layer after layer. In this respect, the speed of drying is a positive asset and because the paint can be applied light on dark or dark on light it is much more versatile than gouache; this feature is bound to be a great help to beginners. This is also a great advantage to professional painters and illustrators who need to work rapidly and usually require accurate colour matching for commercial purposes.

To achieve lighter tones when painting in opaque style, colours can still be diluted with water as required but, more commonly, white is added instead. Two whites are available – Titanium White for general mixing and blending, and Chroma White for really opaque coverage.

Before starting to work in opaque style, it makes sense to see the effect of adding white by mixing Titanium White with each of the colours on your palette. When mixing these paler tones, always add colour to the white, which you will find less wasteful.

▶ *Palette colours with added Titanium White*
It is interesting to see how much the colours change when white is added to them compared with diluting the paints with water for transparent work.

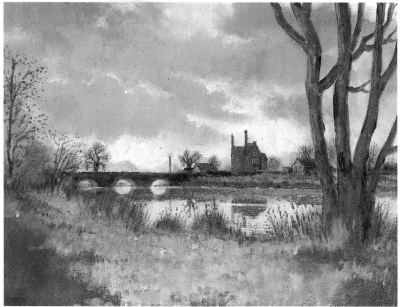

▲ *Michaelmas Daisies*
312 × 480 mm (12¼ × 19 in)
This picture was painted in opaque style, using most of the colours on my palette. The flowers were overpainted on the dark background, but most of the rest was painted light to dark. Chromacolour gives you the choice.

▲ *Woolsbridge Manor,*
Wool, Dorset
280 × 380 mm (11 × 15 in)
This Dorset landmark rises majestically above the river. Clouds masking the sun produce a dramatic effect.

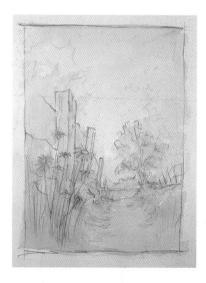

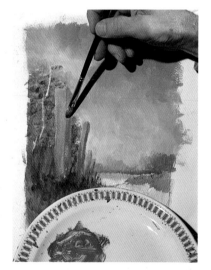

◄ Underpainting the posts
A number of opaque layers are painted to build up the interesting colours in the posts. Each layer is allowed to dry before applying the next, allowing a little of the previous layer to show through. The light tone of the underpainting will create the light edges, which will stand out against the dark of the hedge.

▲ Underpainting for Daisy Trail
A light wash of Raw Sienna makes a sound base, seals the paper surface and still allows the rough drawing to show through. Painting an underwash in varied tones also offers a chance to roughly indicate the tonal areas.

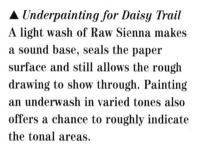

◄ Adding texture – dark on light
A stronger mixture is now overpainted on the posts but leaving the light edges showing against the darkened hedge. A dry brush technique is used to suggest the texture, using brisk strokes with a dryish mixture of paint and holding the brush flat to the paper surface. Even darker paint is used to indicate the deep cracks in the surface; here it is a mixture of Cadmium Red and Ultramarine with a touch of Raw Sienna.

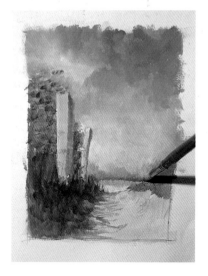

▲ Painting distant trees
Using white to make a pale green, the trees are painted in the far distance.

OPAQUE METHODS AND TECHNIQUES

The opaque nature of Chromacolour means that a gouache-style painting can be built up in easy stages by initially laying areas of flat colour, allowing them to dry, and then overpainting them with more detail.

Country scenes can be depicted very effectively; long meadow grasses, the varied colours on distant fields and hedges, old fences, and wild flowers that adorn the hedgerows can all be placed and painted step by step.

Old fence posts make excellent subjects if you enjoy painting texture. The colours used in *Daisy Trail* are Raw Sienna, Cadmium Yellow Medium, Lemon Yellow, Ultramarine, Cadmium Red Medium and Chroma White. To reproduce light-toned subjects such as daisies, paint the shapes over the dark background using Chroma White, which is very opaque; allow to dry, then overpaint as necessary. This is a good example of using the paint 'dark to light'.

▲ *Painting light on dark*
I do not attempt to paint the daisies with one coat. They are built up in layers like the posts and, to start with, indicated roughly in white paint. Because Chromacolour paint dries waterproof you can continue painting with no fear of the previous layer being affected; with gouache this is not always possible.

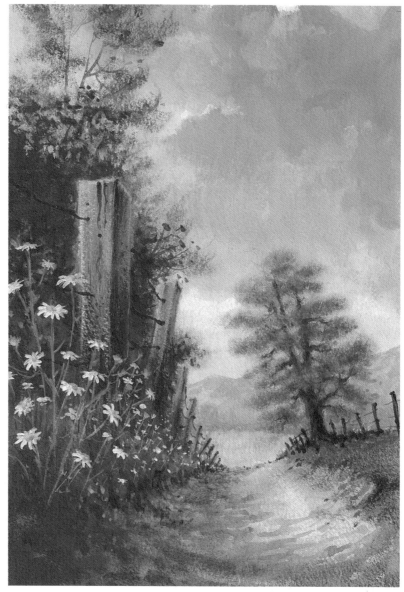

▲ *Final light touches*
The flowers are built up roughly. Small blobs of colour in white and yellow suggest smaller flowers further down the grass verge. Dry brushwork adds more life to the path.

▲ *Daisy Trail*
280 × 455 mm (11 × 18 in)
To finish the picture I painted in some distant mountains and lightened the lower part of the sky. Using overpainting techniques in Chromacolour, you can go on and on building layers until you achieve the effect you want.

In the Style of Acrylic

Acrylic paints have been in use for over 30 years and have a firm following with painters who prefer them to oils because of their bright colours and the fact that no solvents are required. But because acrylics tend to change colour as they dry, it can be difficult to judge how the finished painting will result. They also dry with a dull sheen, so if you want a matt finish, you have to coat them with matt varnish. Acrylic paints are also difficult to dilute because of their 'sticky' texture and the colours lose their vitality. They are particularly hard on brushes.

BRIGHTER BY FAR

By comparison, the specially formulated base resins of Chromacolour paints contain more pigment, giving stronger, brighter colours as well as allowing massive dilution. The result is greater opacity, more vivid colours and no change in colour during the drying period.

Acrylic painters often start with transparent watercolour-style glazes, diluting the paint with water, then build up the painting with thicker layers of opaque paint, lightened if necessary with the addition of white. (For new painters, glazing means to apply a transparent wash that allows the underlying colour to show through.) Chromacolour is ideal because of its flexible nature. In both the light, transparent washes and the heavy areas, it retains its colour and vitality. Use soft sable brushes for light washes and blending and bristle brushes for textured areas where you want the brush strokes to show.

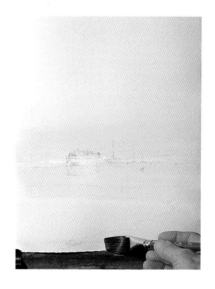

▲ *Underpainting warm colours*
After damping the paper, a thin, graduated wash is applied to the sky and water, using horizontal brush strokes and a mixture of Lemon Yellow, Cadmium Yellow Medium and a touch of Cadmium Red Medium. The sea reflects the sky so the two are painted together to achieve harmony.

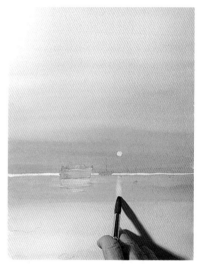

▲ *Overpainting transparent glazes wet-on-dry*
After the first coat is dry, a second graduated wash of Cadmium Red Medium with a touch of Alizarine Crimson is painted, leaving a circular shape unpainted to indicate the setting sun. If you want this to have a soft edge, then apply the overpainting before the first layer is dry. A light streak is pulled out on the water to reflect the sun.

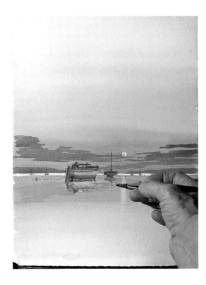

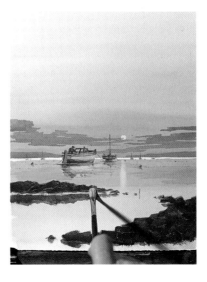

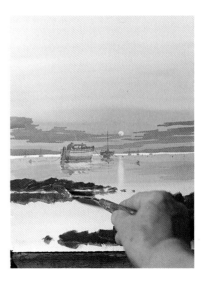

▲ *Overpainting opaque colour*
Darker clouds and distant hills
and boats can be overpainted with
an opaque mixture of Ultramarine,
Cadmium Red Medium, Alizarine
Crimson and Titanium White. The
colours of the fishing boat and
sailing boats should pick up the
colours of the sea and sky. Figures
in this type of scene are usually
described in silhouette.

▲ *Adding opaque rocks*
Using a large bristle brush and
vertical brush strokes, the rocks
are painted, then shadows added
with a darker mix.

▲ *Adding texture to rocks*
Cracks and crevices can be
scratched into the thick paint
surface using a palette knife or old
credit card.

▶ *Sunset*
330 × 255 mm (13 × 10 in)
**Thin transparent glazes and thick
opaque work – this simple, but
effective, way of working is very
straightforward. If the early
washes are spoiled, they can be
overpainted when dry with a layer
of opaque paint.**

COMBINING GLAZES AND OPAQUE PAINTING

The power of Chromacolour
lends itself to bold subjects and
sunsets in particular. A
combination of thin transparent
glazes in the background and
solid opaque work in the
foreground can add great depth
to your painting.

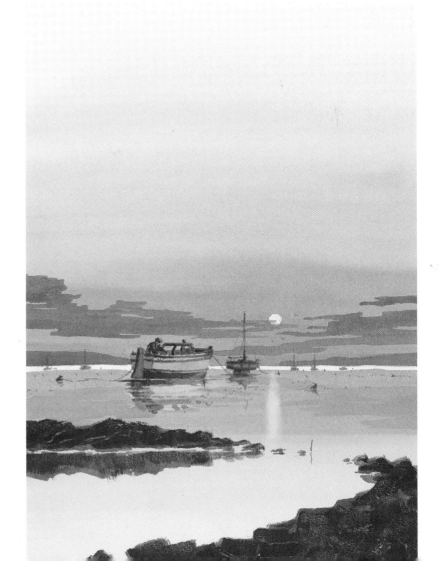

MEDIUMS AND ADDITIVES

You may wish to adjust the colour of a particular area by overpainting with a glaze of another colour. Rather than applying a thin wash, watercolour style, however, you can overpaint with a slightly thicker but still transparent mixture by adding Chroma Extender to the paint instead of water. This will make the paint less opaque without changing the consistency.

If you want your painting to have a shiny finish – and there is no reason why you should not – simply add Chroma Gloss Medium to the paint, which will give it a pleasant sheen when dry. Gloss medium also has the effect of slightly reducing the opacity of the paint. For a higher gloss, apply Chroma Gloss Varnish when the finished painting is dry. This is water based and quick drying, so you will not have long to wait before hanging your masterpiece on the wall for all to see.

If you find the subject of mediums a little complicated at first, just concentrate on using the paint without adding anything to it until you are used to it. Then, as you become more confident, gradually start to experiment with the different additives.

CHROMACOLOUR'S COVERING POWER

Dramatic scenes enable you to unleash the power of Chromacolour to the full, using its strong pigments and excellent covering power. This imaginary coastal scene, *On the Rocks*, is an ideal subject for acrylic-style painting, though it is painted on Bockingford 420 gsm (200 lb) not pressed watercolour paper.

▲ *Underpainting the rocks and waves*
The underpainting is a thin coat of Raw Sienna.

▲ *Overpainting dark rock shapes*
After the underpainting is dry, the heavy rock shapes are built up with a mixture of Ultramarine, Raw Sienna, Burnt Umber and Cadmium Red Medium.

▲ *Using a palette knife*
While the paint is wet, crevices and cracks are pulled out of the paint surface using the point of a palette knife.

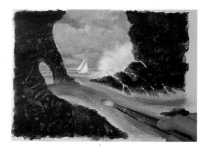

▲ *Overpainting sky and swirling water*
Chroma White is added to Ultramarine and Raw Sienna to paint the sky and swirling water.

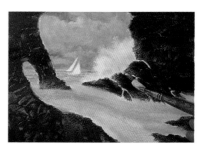

▲ *Dry brush white spray on rocks*
Dry brush and Chroma White bring out the spray that surges over the rocks.

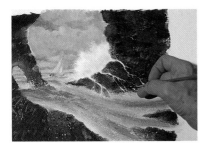

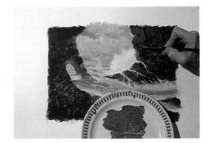

▲ *Painting rivulets of water on rocks*
The fine lines of water running over the rocks are painted with a rigger and Chroma White.

▲ *Glazing using extender*
When dry, the rocks are glazed over to add the reflected colours that bounce up from the swirling water or the rocks themselves. The blue glaze that is used has Chroma Extender added to it.

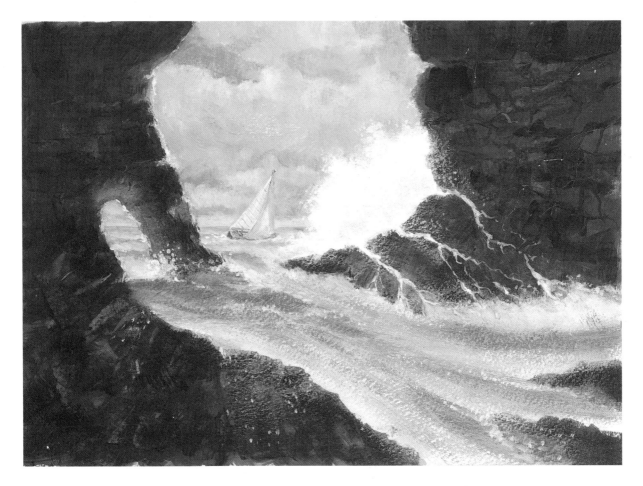

▲ *On the Rocks*
240 × 340 mm (9½ × 13½ in)
A made-up scene in opaque colours. Soft sable and stiff bristle brushes were used as well as painting knives at various stages. Try to leave lots of white for the highlights on the water. The boat colours are subdued, so it stays as a background feature.

In the Style of Oil

Many people avoid painting in oils because of the smell, fumes, risk of fire and very slow drying time. Now, with Chromacolour, it is possible to achieve a similar appearance to oil paint and it is safe, non-toxic and you do not need to spend ages waiting for it to dry.

ADDING BODY TO THE PAINT

Straight from the tube the consistency of Chromacolour is buttery and has a creamy feel to it, but if required, the paint can be made thicker by mixing it with Chroma Gel Thickener. Up to three times as much gel as paint can be added without affecting the colour or flexibility of the paint. The resulting mixture has a very similar feel to oil paint and can be applied in thin or thick layers, using sable or bristle brushes or painting knives.

Adding Chroma Retarder to these thicker mixtures slows down the drying time; this can be really helpful when you need the paint to stay workable longer.

BRUSH TECHNIQUES

In general, if you want your brush marks to show, use bristle brushes, but for a smoother finish or to blend colours together, use soft-haired sable or similar brushes. Both methods can be used to good effect when you are painting skies.

▲ *Underpainting*
Using diluted Chromacolour and a medium round brush, the main areas are outlined and then underpainted using a fairly thin mixture of Raw Sienna. This is dry within minutes, which allows you to start working on any area.

UNDERPAINTING

Painting in the style of oils with Chromacolour is quite straightforward and most of the traditional techniques can be incorporated into your work. You can use pencil, charcoal or thinned paint to loosely draw or paint the outline. Most oil painters start by underpainting their work using a thin layer of paint. I tend to use a similar technique whichever medium I am working with, and a thin coat of Raw Sienna is my usual choice. With

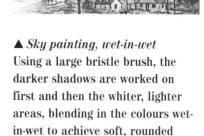

▲ *Sky painting, wet-in-wet*
Using a large bristle brush, the darker shadows are worked on first and then the whiter, lighter areas, blending in the colours wet-in-wet to achieve soft, rounded shapes. A small area is completed at a time, then it is easier to blend.

traditional oil painting one colour to avoid in your underpainting is white, because it can dull the succeeding layers, but this is not true of Chromacolour because of its clarity and covering power. If you use white, bright colours or contrasting colours, or even the complementary colours of the intended finished colours, in your underpainting, these can all enhance the appearance of the final work, especially if some of the underpainting is allowed to show through.

BLOCKING IN

Once the underpainting is dry, most oil painters block in flat simple shapes of colour to indicate the main areas of the painting and then build up the picture step by step. Because oils take a long time to dry, it is customary to work fat over lean – which means applying thin layers early on and the thicker paint later. This is done to avoid the surface cracking, which can happen because of the varying drying times of different colours. When using Chromacolour none of this is necessary, however. No matter how thickly Chromacolour has been painted, when it is dry it remains flexible and does not crack, so the order in which the colours are applied is not crucial. Also, you do not need to add drying agents to speed up the drying time as you often do when using oil paints.

WET-IN-WET

Wet-in-wet means adding more colour before the first layer is dry and is the ideal way of painting summer skies and big, billowing clouds. The colours I used in *Loch Carron, Scotland* were Titanium White, Ultramarine, Raw Sienna and Cadmium Red Medium.

DRY BRUSH AND SCUMBLING

When painting mountains, use a dark colour for the underpainting, then overpaint with a dry mix of lighter colours to give shape and form. For dry brush technique the brush is held flat to the canvas and applied with short, brisk

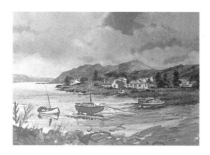

▲ *Dry brush*
The land masses and buildings are dropped in before indicating the trees that will help to define the edges of some of the houses. The shoreline is livened up with dry brush work.

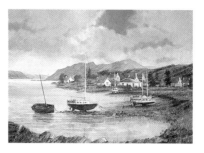

▲ *Overpainting using the painting knife*
Adding Ultramarine to the mixture, the rocks are overpainted with darker colour using a painting knife. To indicate the shadows and crevices and for lighter cracks, a little scraping back with the point of the knife is effective.

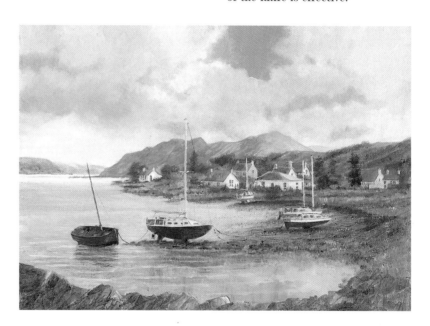

strokes. As each new layer of paint is added, leave some of the previous layer exposed to denote the texture of the terrain.

Scumbling is applying a layer of broken colour to a dry surface, allowing the previous colour to show through in places. This is best achieved with a dry mixture of paint and an upright, stippling motion with the brush.

▲ *Loch Carron, Scotland*
450 × 610 mm (17¾ × 24 in)
I painted this landscape on stretched canvas using typical oil painting techniques with brushes and knife. It is hard to believe that it is is painted entirely with Chromacolour paint and not a real oil painting. Yet it was completed, dried and gloss varnished within a few hours.

STILL LIFE

Still-life subjects are always popular and flowers are invariably the first choice. For this *Flower Study*, a painting of flowers in an earthenware jar, I decided to work on ordinary strawboard to see how Chromacolour would cope with a fairly absorbent surface.

It is important in planning flower studies to ensure that all the blooms do not face you as this gives a flat effect. Arrange the flowers carefully in varied positions and balance the dark and light blooms.

▲ Adding gel thickener
Adding Chroma Gel Thickener to Chroma White gives a more bulky mix. A few spots of Chroma Retarder are also added to increase the drying time.

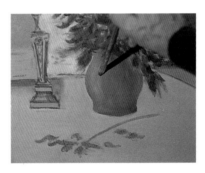

▲ Dry brush
Dry brush picks out the texture on the earthenware pot.

▲ Wet blending the background
The background colours are painted wet-in-wet, with short vertical strokes of the brush, blending the colours to create subtle tones that avoid taking attention from the main subject.

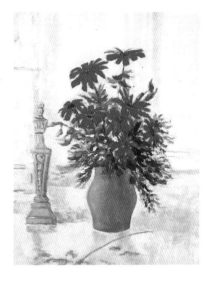

▲ Underpainting the blooms
The blooms are built up in layers, gently blending the paint wet-in-wet.

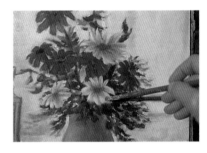

▲ Overpainting the blooms
Stronger colours are overpainted to give more shape and moulding.

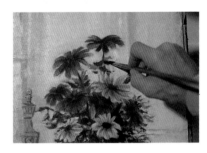

▲ Adding the leaves
The leaves and general foliage provide a dark backdrop to the rich colours of the flowers; these need to be painted loosely.

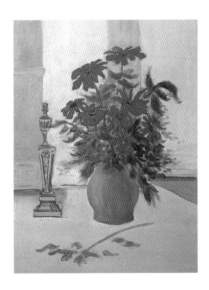

▲ Blocking in
The main areas are blocked in with flat colour.

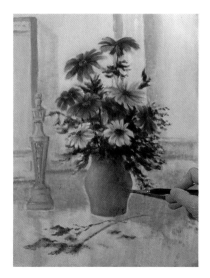

▲ Adding shadows
Shadows cast by the leaves on the side of the earthenware pot emphasize its rounded shape.

▲ Highlights
Lighter streaks on the leaves add sparkle and help the petals to stand out from the background.

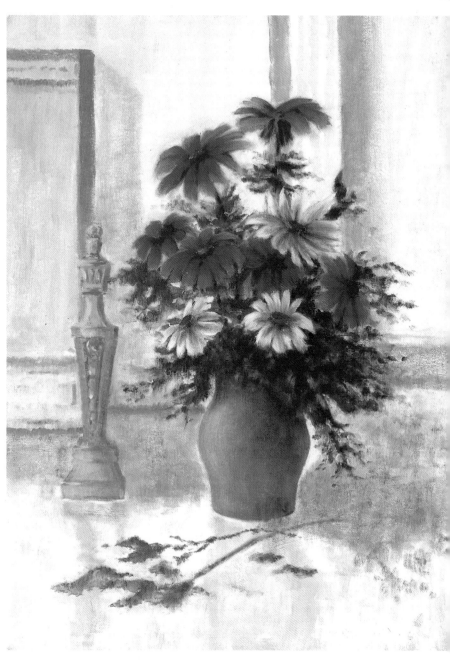

▲ Flower Study
535 × 405 mm (21 × 16 in)
Although painted on thick card, this has the appearance of an oil painting. Chroma Gloss Varnish adds to the effect (and it is water based and quick drying). Who needs expensive canvas?

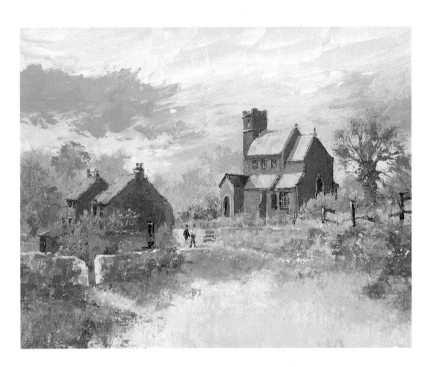

◀ *Morden Church, Dorset*
430 × 585 mm (17 × 23 in)
Painted on canvas board and gloss varnished, this was my first complete painting-knife picture. This is a really enjoyable way of producing paintings that are different, and quick. Chroma Gel Thickener adds the bulk you need.

IMPASTO TECHNIQUES

In impasto painting the paint is applied in thick layers (rather like the delicious topping on Aunty's gateaux). If you are using a brush, then the marks can be clearly seen in the paint. Often, however, artists choose to use a painting knife to create a textured and slabbed effect.

Painting with knives is a very speedy way to work in this style. Each layer can be applied before the previous one is dry, but a little care and planning is required because the painting needs to be built up in a logical order to avoid disturbing previously painted areas. It is usual to start at the top and work down and from left to right.

The paint needs to be a buttery consistency, so Chromacolour in tubes is more suitable than from pots because the paint comes out just about right. Adding Chroma Gel Thickener thickens the mixture and makes it easier to create the heavier, textured effect that is associated with this kind of painting. When applied as an impasto the heavy mixture retains its bulk and texture and, because it is flexible, the surface of the paint will not crack. The heavy layer still dries out relatively quickly, but obviously takes a little longer than a thinner layer.

MIXING

You will need a lot of white to blend into other colours for the paler tints – do not mix white to the colour for lighter tones, but add colour to the white, which is less wasteful. To pick up paint, spread it in a thin layer on the palette and push the edge of the knife into the paint while leaning the knife away from you so the paint builds up on the knife edge.

TYPES OF KNIVES

A palette knife has parallel sides and can be used for mixing the paint. Painting knives have angled blades and cranked handles to keep the hand clear of the painting surface. Use a large painting knife for the broad areas and thin lines, and a small diamond-shaped one for small areas and fine detail.

SCRAPING BACK

For large areas such as skies, paint can be applied in a thin layer, then scraped off to reveal the colour or underpainting below as well as the texture (if any) of the board or canvas. This can be done more than once to good effect, producing an interesting mixture of colours and texture without building up too thick a layer. If your sky contains clouds it can be useful to indicate these first, then pull the blue areas over the top and scrape back to reveal the clouds.

OVERLAYING PAINT

Rectangular shapes such as buildings are ideal subjects for impasto work. In general, you need to work from the roof downwards and left to right (unless you are left handed). This means that once an area is covered it need not be touched again. When scraping down or sideways to release the paint make sure it thins out as you pull it, so that when you overlay the edge for the next area you are not working on too thick a layer. When you are overlaying colour wet-in-wet, remember to have more paint on the knife than on the painting, otherwise the underlying colour may be picked up by mistake. To paint thin lines, pick up a small amount of paint and pull the blade down or across the paper or simply press the blade onto the canvas, leaving a sliver adhering to the surface. Pick up the appropriate amount of paint to suit the thickness of line required.

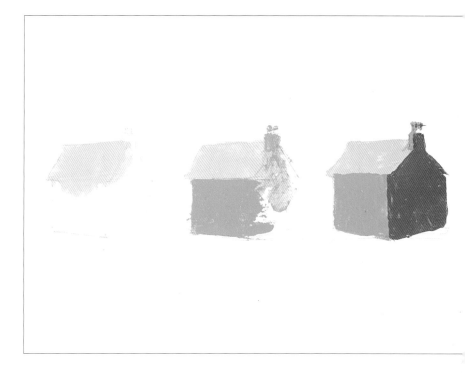

▲ Be patient when constructing buildings in thick paint. Work in a logical sequence, allowing each new coat of paint to overlap the last to create a clean edge.

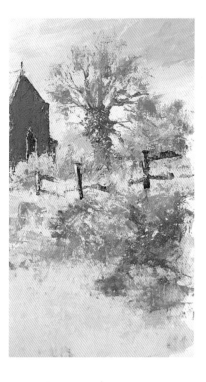

▲ For foliage, hold the knife blade flat to the surface and use brisk strokes. Build up fences by overpainting dark on light, leaving a light-coloured edge for depth.

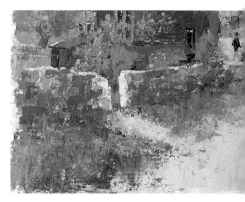

▲ The wall blocks are built up in layers, wet-in-wet, allowing some of the colours to blend for added interest. Avoid making walls too uniform. In this case I painted the light strip at the top of the wall, then pulled darker colour down below it, leaving a narrow edge lightened by sun (Lemon Yellow, Raw Sienna and Titanium White).

The Versatility of Chromacolour

Usually, when a new paint is introduced, it can easily be categorized, but Chromacolour is a medium in its own right. It is not an acrylic, as some people suggest, but a paint that is totally different, with its own characteristics. While it has certain similarities to existing oil and water-based paints, it does not readily fit within the boundaries of traditional media. It can obviously be used to reproduce the style of paintings worked using conventional methods, but it should really be assessed for what it is – a totally new medium. In effect, it is an all-purpose multimedia paint.

Despite initial misgivings on the part of the art establishment, Chromacolour, by virtue of its special characteristics and amazing flexibility, is now accepted as a generic product. Increasingly, paintings are being submitted to galleries and exhibitions described as paintings produced in Chromacolour rather than watercolour or acrylic paint.

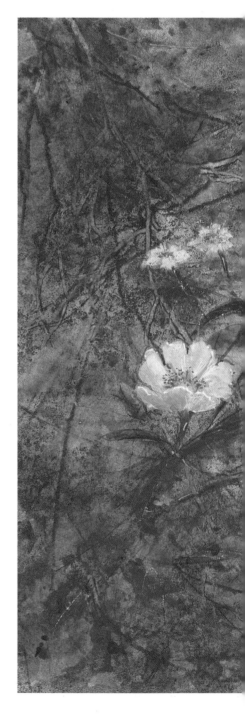

▶ *Dog Roses*
290 × 385 mm (11¼ × 15¼ in)
The distant outlines of trees and fields have been kept subdued to help create a feeling of depth in this painting. Some of the blooms were masked off and others overpainted. The background was built up wet-in-wet with a series of randomly applied washes that were allowed to blend with the board laid flat. Darker paint was flicked on to create added interest.

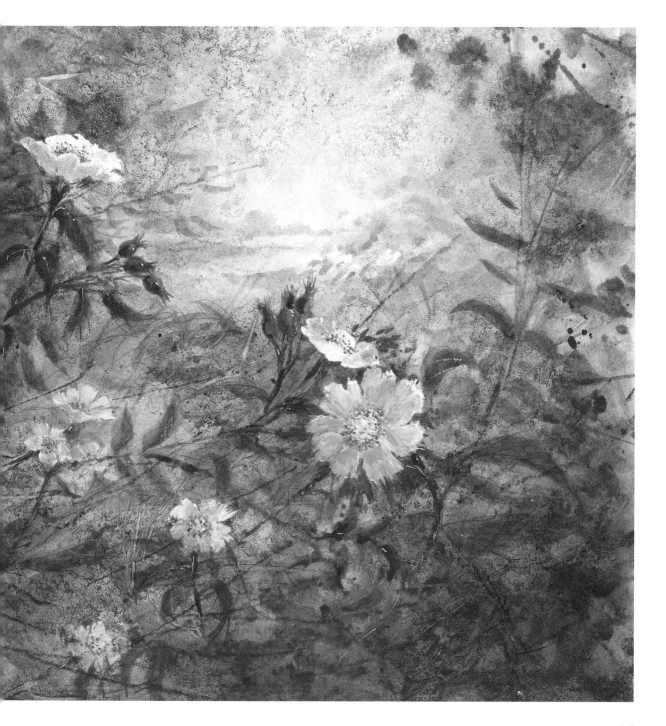

Aspects of Composition

Although Chromacolour gives you the freedom to enjoy your painting more, it is still worth taking a few moments to plan and design your pictures to avoid the obvious compositional faults that can detract from even a well-painted work. Whatever medium I intend to use, my normal approach is to start by producing a small pencil sketch to establish a well-balanced composition. This need only be a very basic drawing with simple outlines to show the main elements. In this way, you can easily try out a number of variations until you arrive at a design that looks right. It is far better to play around with the layout at this stage than to discover a flaw later when you have nearly finished the painting. Always simplify a scene or subject and extract the bare essentials. You are looking to capture the essence of what you see, not every detail.

PLANNING YOUR DESIGN

Regardless of your subject matter the same principles of good design should apply. The finished painting needs to be pleasing to the viewer without any obvious distractions to divert attention away from the focal point or, better still, should contain positive features that guide the eye to it.

Whether you are painting a landscape, animals, birds, buildings or a flower study the same principles can still apply. There are many books written on composition so I shall not go into lengthy details here, but the following points may be helpful.

BALANCE

Position objects and shapes so that your painting does not seem one sided or includes items that appear to be falling out of the frame or are uncomfortably close to the edge. If you were to reduce the main areas of your composition to solid shapes (try half-closing your eyes), they should make an abstract pattern where the darker, positive shapes are counter-balanced by the lighter, less important areas.

▼ A simple pencil sketch helps to establish the best composition and saves time and heartache later at the painting stage.

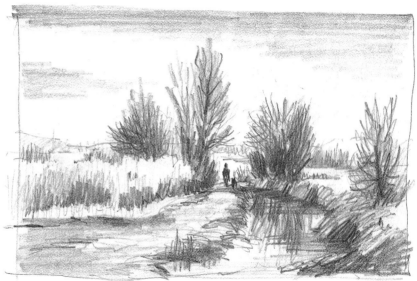

▲ The negative, unpainted or lighter painted areas should balance the main, darker painted areas to form a pleasing abstract, well-balanced composition.

▲ Objects of similar size appear progressively smaller as they recede into the distance.

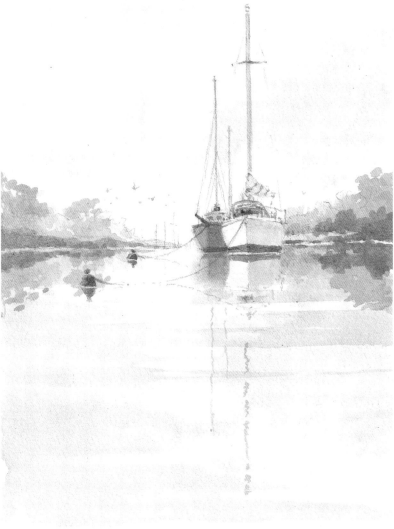

LINEAR PERSPECTIVE

Ensure that the size of distant objects relates to those closer to you, bearing in mind the rules of perspective (a subject that is another book in itself).

Linear perspective describes the apparent reduction in the size of similar objects as they recede into the distance; for example, trees, fence posts or farm animals in a landscape, buildings in a busy street scene, or a random selection of people in a crowd. This variation in size adds to the feeling of depth and dimension in a painting.

OVERLAP ELEMENTS FOR BETTER SEPARATION

This sounds like a silly statement, but the truth is – it is more effective to overlap two or more people, animals, or objects in a painting because it makes them stand out better. If the objects are placed far apart on the paper

▲ This small painting clearly shows how overlapping similar objects of varying size and shape adds interest, the smaller blue boat contrasting well with the larger white one. The dark shoreline also plays a part in making the white hull stand out. The repeating vertical lines of the masts dominate the composition and the upright format helps to confirm this. The horizontal lines of the river banks and darker tones on the water add welcome variation to the scene.

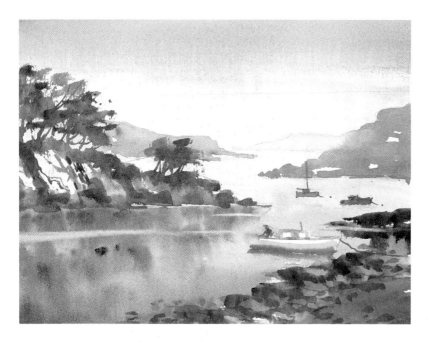

◀ A tonal or value sketch is a useful way to determine tonal contrast before commencing your finished painting. Use a strong colour such as Indigo, Paynes Grey or Burnt Umber because diluting a dark colour gives you a larger range of tones. You can simplify the process by using only three or four shades of the same colour plus the white paper surface. It may help to think of your painting as being a series of vertical layers, each in different tones ranging from light at the back to dark in the front, with mid tones in between.

they can look isolated and have far less impact on the viewer.

If your composition requires two or more similar items, as well as overlapping them, varying the size, colour, bulk or texture will also make them more interesting to the viewer and more prominent in the composition. For example, contrast a tall slim person with a shorter stockier figure, a dark animal with a light one, or a large, textured rock with a cluster of small, smoother stones.

REPETITION WITH VARIETY

Repeating shapes or tonal areas can harmonize your painting, but variety (in terms of size, colour or texture) is essential to keep the viewer interested. If your composition requires mostly vertical objects, such as trees for example, ensure the height, shape and thickness are varied.

Adding a few horizontal lines in the form of fallen branches, a track or river will also add variety, but generally, either the horizontal or vertical lines should dominate

your composition, with the opposing element inserted to add further interest.

CONTRAST

All the foregoing hints and tips relate to contrast in some form or other, although generally they refer to lines and shapes. Just as important is the degree of tonal contrast between the different areas or objects in your painting.

A tonal or value-sketch painting in one colour is an excellent way to make sure that there is sufficient variation between the light and dark tones (values) in your painting to provide the necessary contrast that will make it come to life and appear three-dimensional. Chromacolour lends itself admirably to this approach because you can achieve such a wide range of tones with a single colour simply by adding water (or white if you prefer to work opaque style).

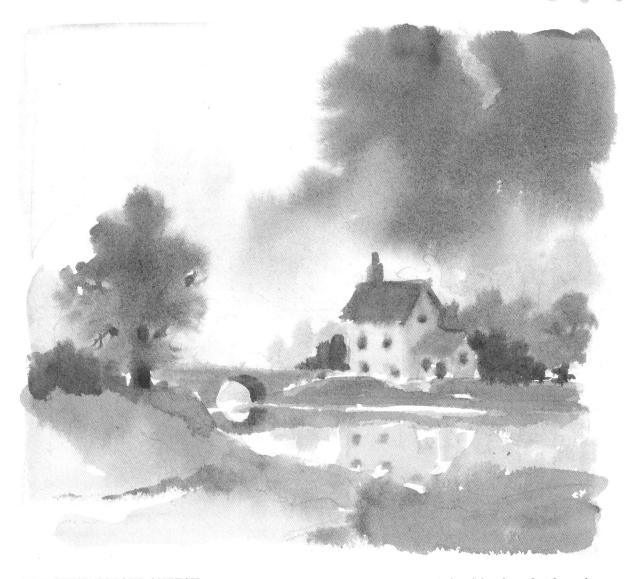

THE QUICK COLOUR SKETCH

A quick full-colour sketch can also be helpful – a simple practice painting speedily executed to give the feel of a scene. This is a good exercise for beginners or for anyone who wants to paint in a slightly more loose style and is often useful when painting on location, when time is short or the weather is unpredictable. Use a large brush such as a 25 mm (1 in) flat for most of the sketch to avoid being too precise. Use transparent techniques or opaque, or a mixture of both, because this sketch is purely for reference.

▲ A quick colour sketch can be useful to capture the atmosphere and mood of a painting and to confirm your choice of colours. Often, the spontaneous way this is done, using perhaps slightly larger brushes and bold, decisive brush strokes, results in a much freer, livelier painting that may well be superior to the finished work. This was a preliminary sketch for the watercolour painting on page 28.

Landscapes

Landscapes are the most popular subjects for leisure painting. The traditional pleasures of visiting the countryside or seaside for holidays, coupled with the greater accessibility provided by modern travel, ensures that many newcomers to painting turn to landscapes as a starting point.

TRANSPARENT OR OPAQUE

In general, when using Chromacolour for transparent landscapes, the paint can be applied in much the same way as watercolour, working from light to dark and leaving unpainted paper for the white areas. However, should the need arise to use opaque paint to highlight or hide an unwanted area, Chromacolour blends seamlessly and unobtrusively into your painting.

Most watercolourists paint from light to dark because it is impossible to paint light on dark without adding white to make the paint opaque or using pure body colour straight from the tube. An overpainted wash would also disturb the first layer. Because Chromacolour dries waterproof, light or dark areas can be painted at any time and, once dry, washes or opaque layers overpainted without any fear of disturbing the previous layer.

Used for opaque landscapes, areas of body colour can be applied straight from the tube and the choice of working light to dark or dark to light is entirely up to you. Overpainting can be done with complete freedom in thin or thick paint, with or without the addition of mediums.

PLANNING A LANDSCAPE

Decide at an early stage whether to have a bold dramatic sky to contrast with a simple, placid landscape or a calm sky over a complicated foreground. If they are both busy it can be confusing. To give more emphasis to the sky use a low viewpoint and position the horizon in the lower part of the painting. To concentrate attention on the main scene, the sky needs to be unobtrusive – a simple graduated wash should suffice. Decide on the direction of light and keep this constant. Work loosely in the early stages and only add detail at the end.

▼ *Sunset and Boats*
340 × 480 mm (13¼ × 19 in)
A poor watercolour rescued with Chromacolour. The dark cloud was overpainted around the sun wet-on-dry.

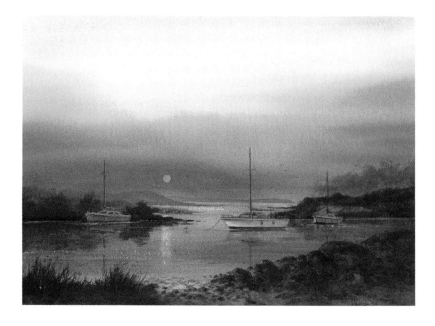

52

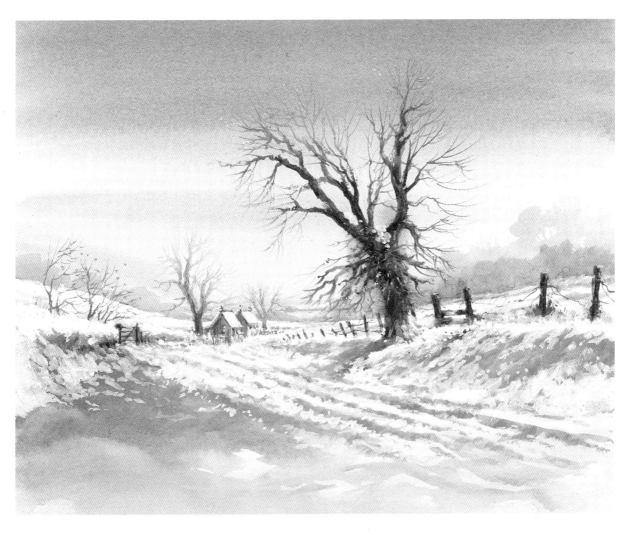

▲ Snow Scene
280 × 355 mm (11 × 14 in)
A classic graduated sky wash and
a traditional winter oak tree
flecked with snow set the scene,
painted using a combination of
transparent and opaque
techniques. Beginners who find
snow scenes difficult may find the
opaque nature of Chroma White
indispensable.

▲ Fishermen on River Bank
295 × 445 mm (11¾ × 17½ in)
Backlighting figures is an effective
way to make them stand out from
the background.

DEMONSTRATION
In the Grip of Winter

I prefer to paint with the board almost vertical. You might like to try this because, predictably, the steepness of the board allows the paint to run down the paper, which adds excitement to the painting process. (Do ensure the carpet is covered first and that you are not wearing your best shoes!) Painting with the board upright also forces you to be more disciplined and discourages the use of excessive amounts of water, the main cause of many ruined paintings.

Step 1
After damping the paper all over with clean water and allowing it to soak in, I applied a pale underwash of Raw Sienna, making sure that it left no hard edges. When this was dry I masked off the large foreground trees using masking fluid.

Step 3
Having removed the masking fluid on the large trees, I painted the distant trees with the blue-grey used for the sky and strengthened them with a darker version of the same colour. I painted the reflections, after first damping the paper.

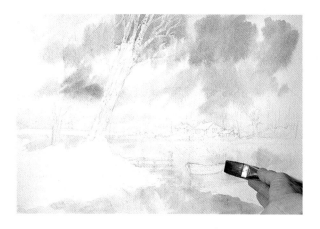

Step 2
I damped just the sky and water areas again. I painted the heavy clouds with a mixture of Burnt Sienna and Ultramarine. The water was painted with matching colours so that it reflected the sky.

Step 4
I painted the walls of the buildings, the jetty and the boat and their reflections with a wash of Raw Sienna, then overpainted the shadow side in a darker mix with Cadmium Red and Ultramarine.

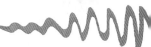

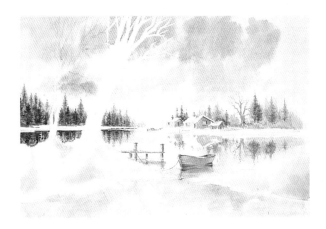

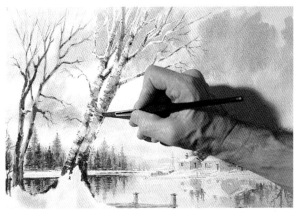

Step 5

To suggest depth to the snow on the roofs I painted a light shadow of Colbalt Blue. I painted a pale pink underwash wet-in-wet on the snow areas, leaving some white spaces as highlights. When this was dry, I painted darker shadows, first with Cobalt Blue, then with Ultramarine mixed with Burnt Sienna.

I painted a pale pink underwash on the silver birches in the foreground.

Step 6

I added darker highlights on the silver birches, overpainting in places with pale violet mixed from Alizarine Crimson and Cobalt Blue. Finally, I added darker horizontal streaks in dark grey (mixed from Ultramarine and Burnt Sienna).

▼ *In the Grip of Winter*

340 × 520 mm (13¼ × 20½ in)

To complete the picture, I damped the whole painting and added a touch of pale violet to warm the sky and water in places. Then I used smooth glasspaper to rub out some highlights on the water.

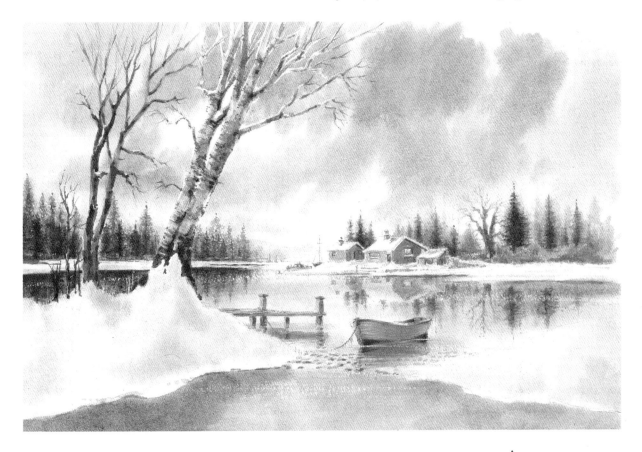

DEMONSTRATION
The Weir

I started this summer scene with my usual underpainting in Raw Sienna with a touch of Lemon Yellow to establish the general tonal areas. I used thin washes of Cobalt Blue on the sky and river, before blocking in the bridge and the various areas of foliage using opaque paint. After the initial work was done, I used white to lighten the colours as necessary and built the painting from dark to light.

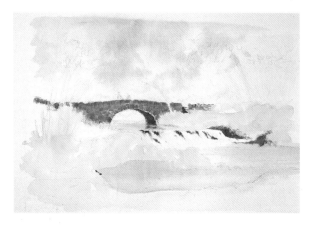

Step 1
I painted a thin underwash of Raw Sienna over the land masses and a glimpse of blue sky (Cobalt Blue) overlaid with darker clouds (Ultramarine, Cadmium Red Medium and Raw Sienna). The dark shape of the bridge and rocks were underpainted, adding more red and blue to the cloud colour plus Burnt Umber.

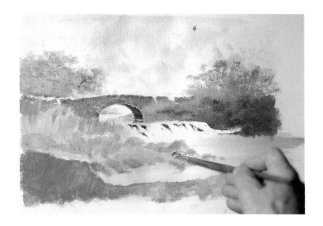

Step 2
I blocked in the trees and banks using Lemon Yellow, Raw Sienna, Cobalt Blue and Ultramarine. The rocks were Cobalt Blue and Cadmium Red.

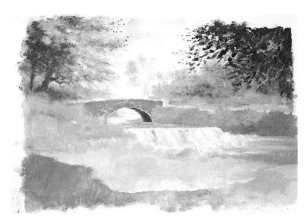

Step 3
I started overpainting the foliage with stronger colour, using dry brush to blend the various tones together and painting dark overhanging branches adding a touch of Prussian Blue to the mixture.

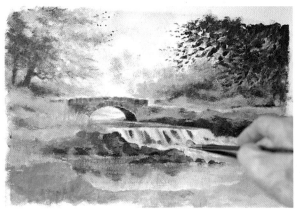

Step 4
I used brisk horizontal strokes to bring out the light sparkling on the surface and vertical strokes to indicate the streaks of water rushing over the weir.

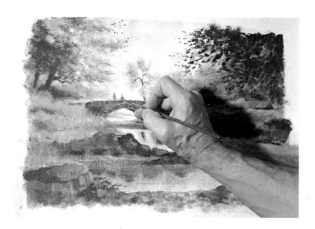

Step 5

For added interest I painted in a couple of figures on
the bridge. As they were quite distant I avoided too
much detail.

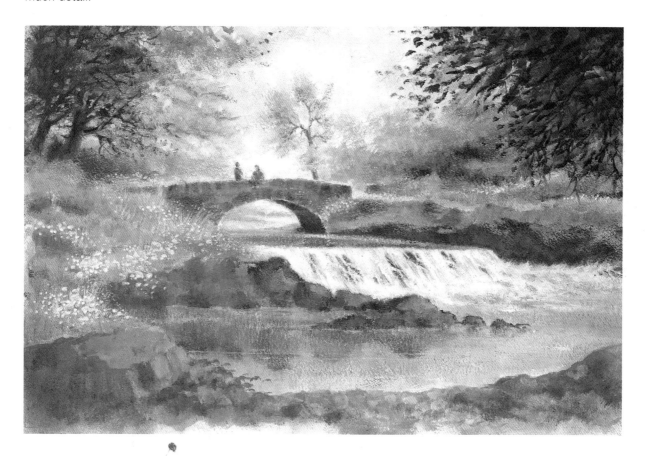

▲ *The Weir*

280 × 405 mm (11 × 16 in)

I mainly used Chromacolour straight from the tube
here, plus a little transparent work. If an area dries
out and you wish to blend in more colour, damp the
surface, allow it to soak in briefly, then stroke on
your opaque paint, blending it gently on the damp
surface.

DEMONSTRATION
Mountain View

Knife painting is a quick and easy way to reproduce snow-capped mountains. With Chromacolour the paint dries quickly, so when you first start to paint using a knife, allow each coat to dry out before applying the next layer until you build up confidence. You can try out the techniques even if you do not have painting knives by using stiff card, an old credit card or shaped pieces of plastic. If you can, treat yourself to a couple of painting knives because you really can have fun applying the paint in thick layers. This simple scene is an ideal subject for the newcomer to impasto. I would recommend the use of board in preference to paper as a support, because the less flexible surface will be easier to work on. I used watercolour board, primed with two coats of Chroma Gesso Primer (to cover up an old painting).

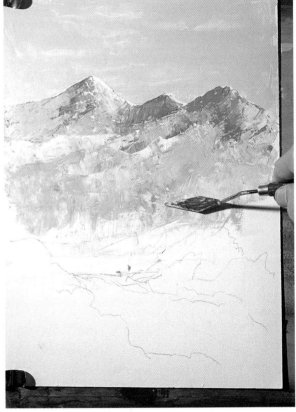

Step 1

On my glass palette I prepared a good quantity of white. I used Titanium White thickened with Chroma Gel Thickener and added a few drops of Chroma Retarder to slow down the drying time. I painted the sky with a thin coat of pale blue mixed from Cobalt Blue and Titanium White, pulling it down over the top of the mountains with the knife.

Step 2

I pulled a thick mixture of white paint down over the bottom of the sky to form the mountain peaks, taking care not to disturb the sky colour. I smeared the sunny side of the peaks with a light touch of pink and overlaid this in places with pale Cobalt Blue.

I used Ultramarine to paint in the shadow side of the peaks and the upper slopes and added a touch of violet (mixed from Ultramarine and Alizarine Crimson) in places for added interest.

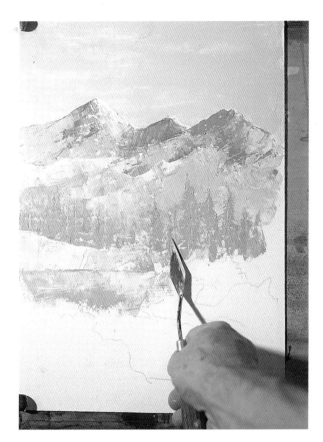

Step 3

I continued painting the lower slopes in white and pale blue and suggested a horizontal strip of water that reflected the same colours. Then I added Lemon Yellow to the Cobalt Blue mixture to paint the distant fir trees. I used vertical strokes with the knife edge to suggest the trunks of the trees, then holding the blade flat to the paper I pulled out the foliage with brisk sideways flicks, avoiding the temptation to be too detailed.

Step 4 (below left)

I added Ultramarine to make a darker green and, using the same technique as before, flicked in some darker foliage on the nearer line of trees. I also took some of the tree colours and smeared it onto the water area as reflections.

▼ *Mountain View*

380 × 280 mm (15 × 11 in)

To complete the painting, I painted rocks and snow in the foreground adding Cadmium Red Medium, Alizarine Crimson, Burnt Sienna and Raw Sienna to the colours already in use.

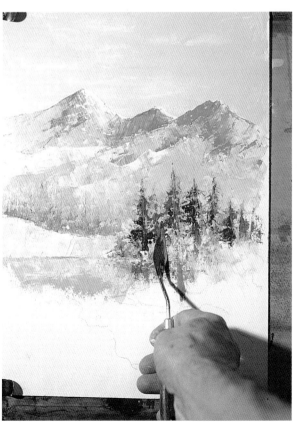

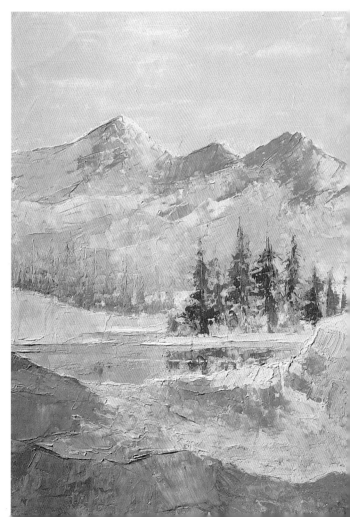

RURAL VIEWS

Guest Artist
Sheila Sanford

Sheila's charming pastoral scenes capture so well the peacefulness of the traditional British landscape. The warm, yet soft, colours and clean lines show clearly how Chromacolour's powerful pigments can be harnessed to produce a quiet mood.

▲ *The Chapel on the Hill, Abbotsbury, Dorset*
225 × 305 mm (9 × 12 in)
Sheila wanted to convey a quiet early morning with long shadows that emphasized the ancient lynchets on the hill and the hazy sun striking the tops of the trees. She had originally painted another house but it was too intrusive. Using Chromacolour, she was able to delete it and add a softer weight by introducing the trees.

▲ *Cows Grazing*
215 × 300 mm (8½ × 11¾ in)
Driving one day near her home, Sheila saw a herd of Friesian cows looking as though they were eating their way up the side of the hill. She kept the picture in her mind for several days until she was able to paint it. This was the first time that she had used Chromacolour. She particularly liked the way the sky turned out, a lovely clear blue, a mixture of Ultramarine and Cerulean Blue.

▶ *Pines, Malvern*
300 × 215 mm (11¾ × 8½ in)
Sheila liked the way the slim trunks of the trees dissected the view of the sunlight on the distant town. With Chromacolour she was able to paint in the background and then add the trees and the foreground without disturbing the earlier work.

WATERSCAPE

Guest Artist
Dennis Hill

Dennis is a very experienced painter who has taught and demonstrated for many years and whose work has graced many galleries. He was introduced to Chromacolour only recently and has quickly found ways to reproduce the lovely transparent washes that make his landscapes so distinctive.

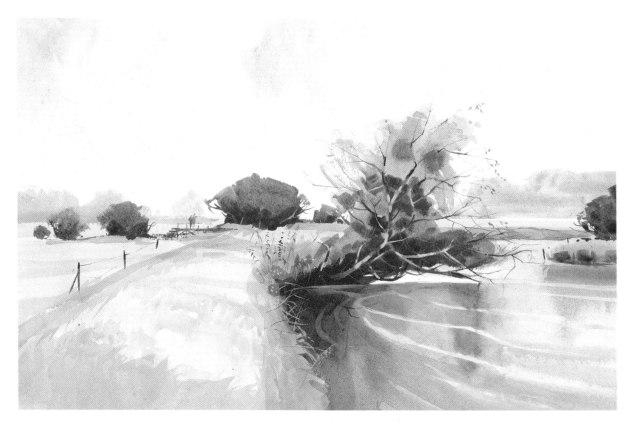

▲ Summer Landscape
345 × 530 mm (13½ × 21 in)

The first part of the painting was treated like a watercolour. The sky was washed in with plenty of water using Cobalt Blue and Raw Sienna with a touch of Burnt Sienna and Ultramarine. Then the distant trees were added, using Ultramarine greyed with Burnt Sienna, and the bushes in the middle distance were put in with a strong mix of Phthalo Blue and Burnt Sienna. The greens for the grass were mixed from both warm and cool yellows and blues. When dry, glazes of Prism Violet and Raw Sienna produced shadows. Similar mixes were also used for the overhanging tree.

The water was painted with mixes of Ultramarine and Burnt Sienna. The sunlit branches of the tree were applied using opaque Chromacolour in the style of gouache, with a mix of Titanium White and Yellow Ochre. In the closing stages, final touches were applied by glazing when colour needed changing slightly.

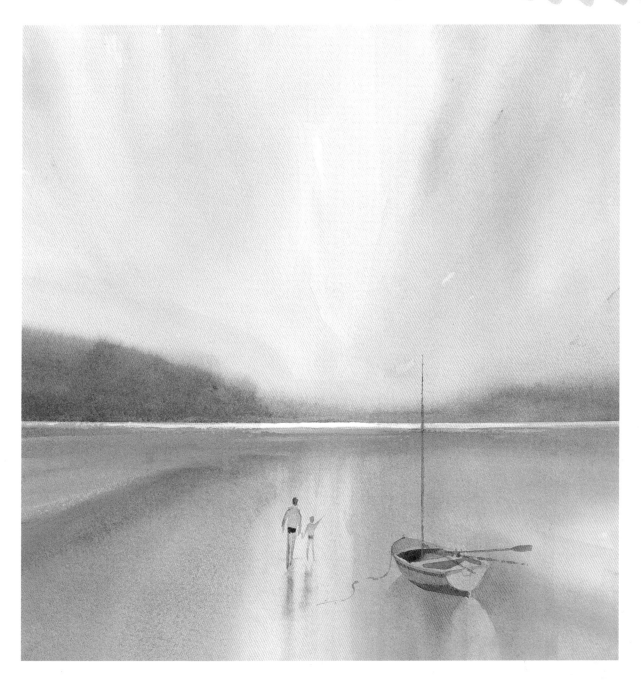

▲ *Summer Bliss*
350 × 335 mm (14 × 13¼ in)
This imaginary scene was painted mostly wet-in-wet using lots of water. Dennis started with a very fluid wash of Raw Sienna and dropped in Cadmium Orange, Magenta Medium and Prism Violet while the paper was still wet. He worked down to the horizon line, which was left roughly unpainted.

The beach was completed with similar applications of colour with Burnt Sienna and Prism Violet used to add slightly darker areas.

The tree line was added before the top area dried out, using Ultramarine and Burnt Sienna. When this was dry he tidied up the horizon line using Titanium White, then painted the figures and boat wet-on-dry, softening the edges of the reflections with clean water.

The colours blended together beautifully when flooded generously and used in this way Chromacolour behaves like a traditional watercolour paint with the added bonus that, when dry, the washes are 'fast'.

Flowers
and Plants

Flowers lend themselves to treatment in various ways. Chromacolour is ideal for very precise work and equally suitable for looser studies. The best way to free up your approach is to include less detail when drawing your subject and paint with larger brushes, using both wet-in-wet and wet-on-dry techniques whether using your paint transparent or opaque. You may find some additional colours useful for flower painting. The huge range of hues offered by Chromacolour allows you to really experiment and the vibrant colours and subtle shades that can be achieved in both transparent and opaque styles are a great help.

If you are considering painting flowers, here are a few pointers to stimulate your ideas.

GARDEN FLOWERS

Cultivated flowers and plants make excellent subjects whether pictured as single specimens or clusters *in situ*, although in some cases their appearance may be short lived. If you are unable to paint them on the spot, photograph them and use these for reference later. Take both close-ups and wide-angle shots if your camera permits.

DRAMATIC BACKGROUNDS

To make your paintings more dramatic, you may like to try a semi-abstract background. The larger flowers can be masked off if you are working in transparent style; alternatively, they can be overpainted afterwards. If you roughly paint in the main stems and leaves and allow them to dry, the whole painting can then be washed over with a series of different colour glazes and strong blobs of paint flicked onto the wet surface. Not only is this great fun, but the process actually produces some interesting results, especially if you leave the board horizontal while the paint dries.

▼ *Masking off blooms and underpainting*
I applied an underwash of Raw Sienna and Lemon Yellow before covering the blooms with masking fluid. I was then able to apply a random abstract background with complete freedom.

colours onto the background area
and allowed them to swill about
while holding the board horizontal.
I helped the paint on its way using
the brush and a small garden
spray. The paint settled on the
rough paper surface in random
fashion, creating interesting
patterns and textures.

▲ *Throwing on paint with a
big brush*
After roughly painting the leaves
and stems, I used a 25 mm (1 in)
brush to flop lots of different

▲ *Underpainting the blossoms*
After removing the masking fluid,
I built up layers of transparent
and opaque colour on the large
flower heads.

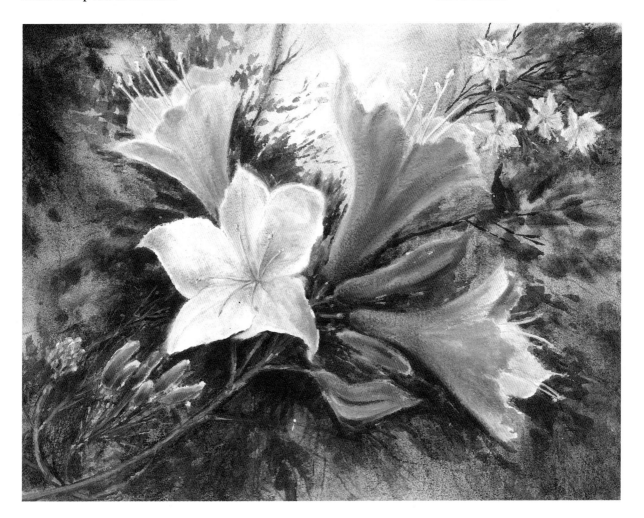

▲ Azaleas
345 × 460 mm (13¾ × 18¼ in)
These huge Azalea blooms were
growing in my garden and as I had
no time to paint them, I took a
quick photograph. They fell
naturally into this interesting

arrangement, so I had little to
change for the painting.

FLOWERS IN THE STUDIO AS STILL-LIFE SUBJECTS

Flowers make popular still-life subjects and are readily available to most of us at certain times of the year. Make sure your flowers are arranged to best effect – look for a well-balanced design and a harmonious colour scheme. Use the same principles of design you apply to painting landscapes or portraits.

Create variations in tone by using the dark shadow areas and deep colours of the foliage to contrast with the lighter, fresher colours of the flowers. Avoid flat-looking frontal lighting, but look for more interesting positions that emphasize the shapes of the blooms, the delicacy of the petals and the texture of the leaves.

▲ If you find arranging and drawing the flowers difficult, imagine that they are wine glasses with elongated stems and draw them in various positions. Hold real glasses at various angles in front of you to get the idea.

▼ *Rhododendrons*
312×413 mm ($12\frac{1}{4} \times 16\frac{1}{4}$ in)
In this sketchy, transparent treatment of rhododendrons I used Alizarine Crimson and Cerulean Blue for the flowers and Lemon Yellow, Cadmium Yellow Medium, Raw Sienna and Ultramarine for the foliage. I painted it quickly and loose to try and achieve the light softness of the blooms.

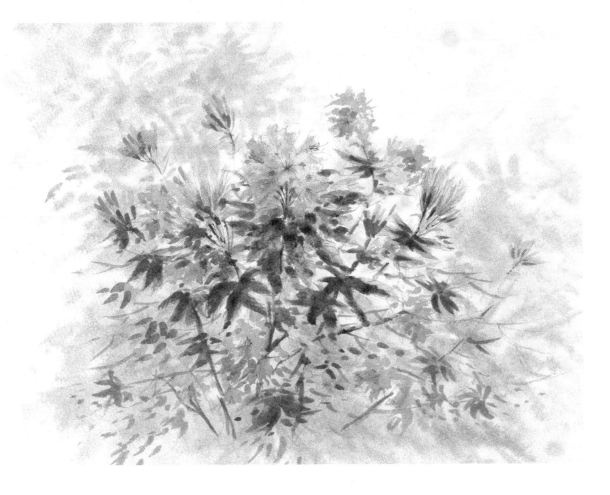

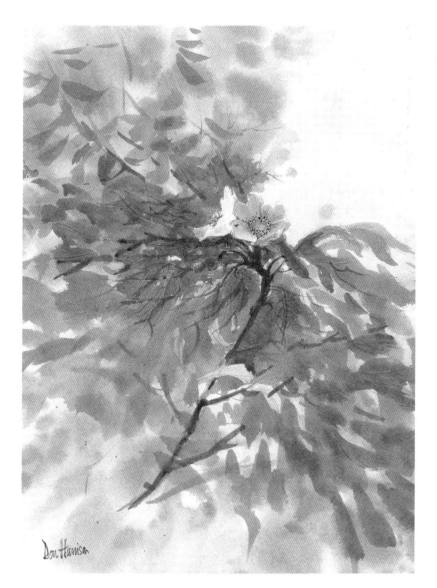

◀ Light against dark, and dark against light
Painting dark negative shapes creates the white or light edge of a flower shape. Paint wet-in-wet for a soft edge and wet-on-dry for a crisp edge. Dark petals will show up well when painted against a light background such as the sky or another light flower or leaf.

FLOWERS IN THE WILD

Wild flowers are growing in greater numbers now that people are more aware of their responsibility to the environment. It is always a pleasure to walk down a country lane and discover a cluster of delightful flowers growing in the hedgerow or by the side of the track. If you cannot paint them on the spot, photograph them for reference to paint at a later date at home. Remember that white flowers on a dark background may fool your camera's exposure meter, so decrease exposure by one or two stops and for flowers photographed against the light, increase the exposure by the same amount.

Including wild flowers in the foreground of a landscape painting can be very effective, especially if the background area is painted with less detail and in paler colours. This can add a new dimension to your landscape painting. The foreground flowers can be shown larger than life and distant objects will be quite insignificant by comparison.

Paint flowers so that they look alive. So many people paint flowers by filling in a solid outline, leaving no sense of softness or subtlety. Use wet-in-wet techniques when painting thin, or soft blending when painting thick, to leave edges slightly loose. To create hard edges on petals, do not paint the outline, but paint an appropriate dark or light negative shape around the petals to create the impression of an edge. This is the same principle as suggesting snow on the roof of a building by painting dark trees behind. Foliage can also be used for this purpose when painting flowers.

DEMONSTRATION
Apple Blossom

Tree blossoms make wonderful subjects although they are usually in flower for only a short time, so once again the camera can be a useful ally. The delicate nature of blossom can be captured beautifully, using the transparency of Chromacolour to good effect. To produce the pale tints of the petals the background needs to be carefully arranged to produce the right degree of contrast.

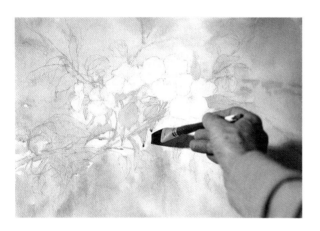

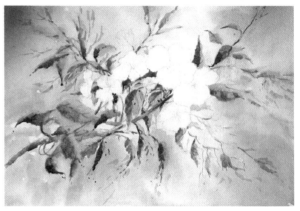

Step 1

I decided to omit any underpainting and proceed straightaway with the background, which I wanted to appear loose and free to suit the delicate nature of the blossom. I worked both wet-in-wet and wet-on-dry, starting from the top left corner where the branch would hide any overlap of paint, and allowed the various colours to mix on the paper (Raw Sienna, Cadmium Red Medium, Alizarine Crimson, Lemon Yellow and Cobalt Blue). I carefully painted around the blossoms, but not too precisely.

Step 2

Adding a little Ultramarine to the paint mixture, I darkened the foliage and added vague shapes of leaves, working into the damp paper to retain the subdued and soft effect.

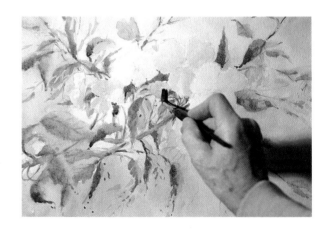

Step 3

I damped the blossoms and painted a delicate pink edging using diluted Alizarine Crimson.

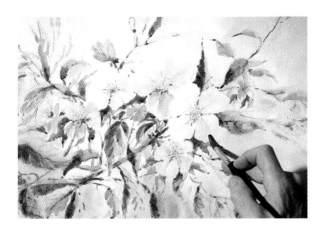

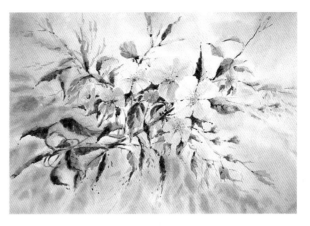

Step 4

I painted pale blue and violet shadows onto the petals and varied the colours for added interest.

Step 5

I decided to strengthen the foliage and painted a few darker highlights using Ultramarine and Raw Sienna. When dry I damped the painting and darkened the background at the top left and bottom right to improve the tonal contrast, dropping in muted tones of green and blue-grey using a large brush.

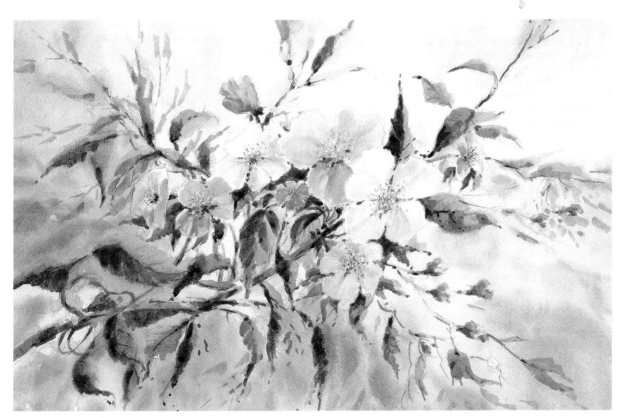

▲ *Apple Blossom*
340 × 520 mm (13½ × 20½ in)
Transparent techniques seemed most suitable for this subject. I did not mask off the petals, but painted round them to keep them loose. A background of random foliage helps focus attention on the blossom.

VIBRANT FLOWERS

Guest Artist
Sue Wales

Flowers feature strongly in Sue's work and her wonderful home and garden provide her with plentiful subjects. She uses Chromacolour in a variety of ways and exploits the full power of the colours to great advantage, yet combines this with subtle touches that make her work highly distinctive. She always lays out all her colours so she can constantly dip into them and tries to use brushes that are as big as possible to keep the painting from becoming overworked.

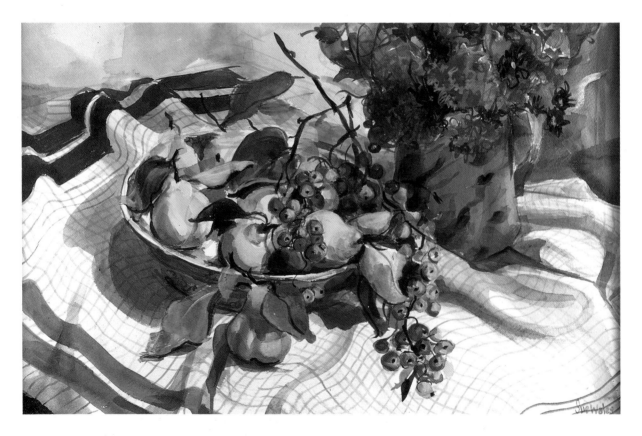

▲ *Bowl of Quinces*
710 × 355 mm (28 × 14 in)
Painted on Bockingford 300 gsm (140 lb) watercolour paper.
Here Sue treated Chromacolour as pure watercolour – starting by mixing an extremely watery blue wash and 'drawing' with a brush.

She dropped in the background with further watery washes and started to shape the bowl. Basic washes were placed to give local colour to the quinces and leaves.

Sue always works very fast at this stage of the painting, trying to get the tones right and keeping the picture balanced. She builds up colour, defining some areas and leaving others loose, thickening up as necessary with the paint.

One of the final touches was the small checks on the cloth. Here Sue really had to concentrate, yet retain the original loose feel.

70

▶ *Christmas Roses on Indian Cloth*
330 × 480 mm (13 × 19 in)
This was painted on card as Sue felt that she needed a fairly muted background. She blocked in the light tones, then laid coloured washes over the petals to give them a luminous quality. The cloth was worked using the paint thick and thin, softening the edges but sharpening up other areas.

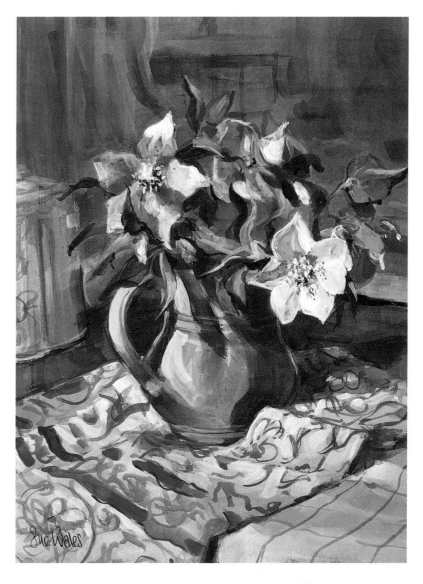

▶ *Hot Sunny Day in my Garden*
760 × 510 mm (30 × 20 in)
Sue used card for this painting as it immediately gave her a mid-colour ground to rapidly find the 'darkest darks' and 'lightest lights'. Some foreground areas were painted in quite thickly whereas the dark trees and windows were placed in with loose washes. The flowerbeds were gradually built up in layers, thickening up the paint as the painting progressed.

BOTANICAL STUDIES

Guest Artist
Chris Christoforou

For the botanical artist, the pure colours, smooth finish and waterproof nature of Chromacolour paints are ideal. Chris, in particular, has helped to establish awareness of the full qualities of these paints. His accomplished demonstrations and detailed wildlife and bird studies in Chromacolour have also prompted many people to take up painting as a hobby. Here he demonstrates step-by-step his own technique for producing a detailed flower study.

Step 1
Chris first made an outline drawing on tracing paper, then transferred this onto watercolour board using 'tracing down paper'.

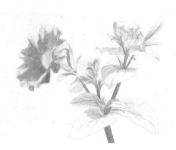

Step 2
All leaf and stem areas were underpainted using Chromium Green Oxide. The flower head was painted in Magenta Medium and the stem in Unbleached Titanium. The flower head was then masked out.

▶ **Step 3**
Chris applied a thin wash of Sap Green on wet board, graduating it towards the bottom of the painting. While the wash was wet Manganese Blue was added from the bottom and graduated upwards to blend in.

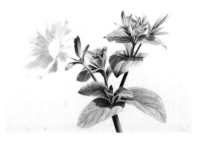

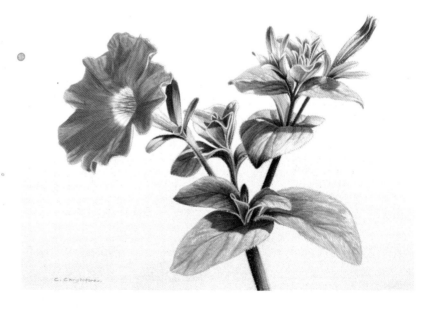

▲ *Petunia*
165 × 205 mm (6½ × 8 in)
To complete the painting the detail in the leaf and stem areas was first painted with a wash of Cadmium Yellow Light, then worked in with Sap Green and Hookers Green for the darkest areas. Titanium White was used for the highlighted areas.

WOODLAND FLOOR

Guest Artist
Edwin Cripps

Edwin uses Chromacolour for a wide range of subject material, including landscapes, flowers and murals. Having worked with all the traditional media extensively, Edwin now finds that on its own Chromacolour fulfils all his requirements. He turns out an amazing variety of work, from detailed flowers to exotic fantasy paintings as well as huge, striking plant studies, some of which leave little room for him in his small studio.

▲ *Boletus*
560 × 370 mm (22 × 14½ in)
Edwin applied four or five coats of Chroma Gesso Primer on an MDF (medium density fibreboard) panel, each coat sanded smooth. He predetermined a dense composition of dead leaves and fungi, making a rough sketch on paper with ballpoint pen. Once satisfied with the composition he 'drew' the picture faintly onto the prepared surface with dilute paint.

Using the pure white of the ground, Edwin painted all the pictorial elements directly with no underpainting, enabling the colours to glow.

He used artificial greens as contrast – a compositional device to complement the browns and ochres of the fungi and dead leaves. The Chromacolour permanent greens (light and deep) proved to be not only opaque but very vibrant, giving exactly the result intended.

Animals and Birds

Animals and birds make interesting subjects – whether in domestic, countryside or sporting environments, or in the wild – and the clarity and strength of colour obtainable from using Chromacolour is ideal for this type of work whatever technique is employed. Including animals in a landscape helps to give it scale. They can also be used to provide a focal point or painted individually as subjects in their own right.

ACHIEVING THE RIGHT PROPORTION

For beginners, painting animals can be daunting. To simplify the drawing process, use a grid as an aid to achieving the right proportions. It is easier to draw a shape within a set framework.

TONAL SEPARATION

Farm animals and birds make wonderful painting subjects, either singly or in groups, but when it comes to the painting stage, problems usually occur in separating animals from their surroundings, especially if they are white or very dark. The answer is to use tonal contrast to isolate the animals, placing light animals on dark backgrounds or against darker animals and dark animals against light. This tonal separation plays a big part in all aspects of painting.

If the subject is white or a very light colour like a goose or swan, paint it first, then add the background around it, or paint the background first, leaving the required shape as white paper. Alternatively, overpaint the subject afterwards using opaque colour. With Chromacolour it is easy to build layers of colour to achieve the right effect.

Backlighting can be very effective because it offers the opportunity to paint a light halo around the edge of the subject, which makes it stand out from the background.

◄ *Polo Ponies in Action*
312 × 480 mm (12¼ × 19 in)
Photographs were used to capture the action at this charity polo match. The low-level viewpoint adds to the excitement of the event. The painting is achieved with a mixture of transparent and opaque techniques.

◄ Horses in the Snow
295 × 535 mm (11½ × 21 in)
The underpainting shines through the overpainted transparent glazes in this snow scene. I watched the horses in the field across from my home and took a quick photograph to capture the unusual position.

▲ *Swan*
250 × 300 mm (9¾ × 11¾ in)
Painting white subjects in opaque style offers more choice of methods working light to dark or dark to light. Usually, the subject is painted light on dark with opaque overpainting. Subsequent work to establish tonal variation can be painted thin or thick as required.

DEMONSTRATION
Through the Mist

In general, wildlife paintings can be divided into two categories: realistic, detailed studies with an almost photographic quality; and looser work in which there may be less detail, but more sense of atmosphere. Some artists even manage to blend these two characteristics successfully. The emphasis in your own work will vary according to your own style and preference, but Chromacolour is widely accepted by wildlife painters as being ideally suited to this type of work.

Step 1
This deer is a frequent visitor to my garden, but I decided to paint it in a more atmospheric setting in a fairly loose style. After damping the paper, I applied a varied wash of colours, mixed on the paper wet-in-wet (Raw Sienna, Cadmium Red Medium and Lemon Yellow), leaving a light area below the trees on the right to suggest a band of mist.

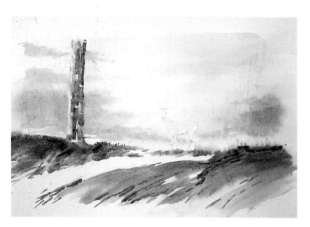

Step 2
I built up the background wash, warming up the lower part of the sky and suggesting soft banks of cloud in neutral tones, adding a little Cobalt Blue at the top and warmer, more red-violet tones at the bottom. I continued into the foreground area using a 25 mm (1 in) flat brush to add darker directional slabs of colour and strengthening the paint mixture with Ultramarine and Burnt Sienna. At the same time, I painted the large tree on the left using the same colours.

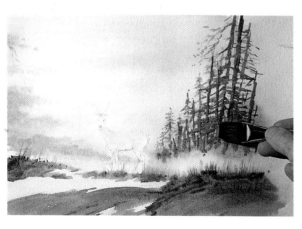

Step 3
After damping the paper in the misty area, I used a pale mixture of Burnt Sienna and Ultramarine and the 25 mm (1 in) flat brush to paint the fir trees. Using the chisel edge of the brush and short sideways strokes, I created the impression of trunks rising out of the mist and used the same brush to dab in the foliage. As the paint dried I added darker tints on the trunks of the nearer trees to give more depth.

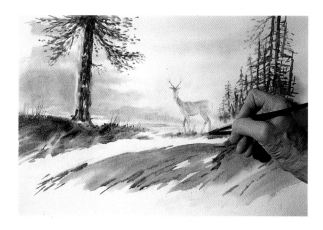

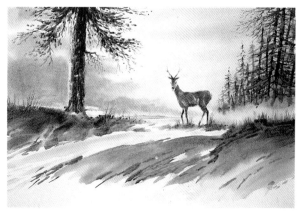

Step 4

I painted the distant hills using a pale blue-grey and added the foliage hanging down from the big tree. I put more colour on the deer, using Raw Sienna, Burnt Sienna and Ultramarine.

Step 5

With a slightly darker mix I added shading and limited detail to the deer and the large tree. Finally, I added a touch of colour to the track.

▲ *Through the Mist*

320 × 480 mm (12½ × 19 in)

A low viewpoint makes the deer stand out boldly against the skyline. Try to be imaginative to improve your composition. A fairly restricted palette creates a harmonious, warm appearance.

On the Farm

Guest Artist
Hazel Lale

Hazel has a wonderful loose style which should be a lesson to us all. Yet she captures the life and movement in her subjects so well. The brilliance of Chromacolour shines through all her paintings and gives them added impact.

Hazel paints in a simple direct manner to determine the essence of her subject in the fewest possible brush strokes, taking advantage of the natural characteristics of the paint. Her painting is fundamentally about colour; for example, painting more than one colour, allowing it to flow and merge into areas of similar value or leaving white paper before starting to paint adjacent shapes.

She starts by exploring the composition with a tonal drawing. Working out the tonal value of her subject helps to decide where the light source is and establish the form. She then does an outline of the subject on watercolour paper and commences painting. Initially she uses watercolour techniques for the first washes and introduces thicker mixes at later stages, similar to impasto techniques. The brilliant range of colours offered by Chromacolour allows her the freedom to just go ahead and paint.

Step 1
Using a size 20 round brush, a light value wash of Cadmium Yellow Medium and Cadmium Red Medium was painted over the cockerels, allowing the brush strokes to suggest form, and some of the colour was painted onto the background.

Step 2
A Burnt Sienna wash was put into the wet background, allowing the first wash to show through the lightest parts of the form.

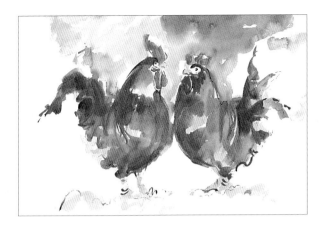

Step 3
Using a drier mix, the darker areas of the birds were emphasized with Burnt Umber and Ultramarine.

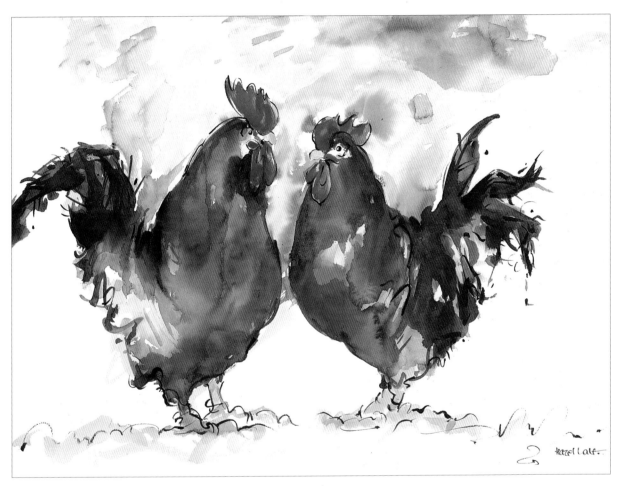

▲ *Cockerels*
560 × 735 mm (22 × 29 in)
With a size 8 round brush Hazel painted the dark
value areas of the birds and put some definition in
the tail feathers with an Ultramarine and Burnt
Umber mix. She completed the painting by putting
in the details of the eyes, head and feet with a
size 1 brush.

BIRDS IN MINIATURE

Guest Artist
David Cook

David has changed from painting with acrylics to Chromacolour as he finds it more agreeable to use, more forgiving if errors occur and far more versatile. He prefers the pots, as he tends to use the paint direct in its creamy consistency and, increasingly, watered to transparent glazes. Being able to drift coloured tone over dried tones and other colours can give some remarkable results.

Step 1
Working from a page of pencil sketches, a portrait was selected for the miniature painting. Daler-Rowney Museum Board was chosen as a painting surface because of the archivist neutral ph quality.

The surface has a tooth akin to 'not' or 'cold-pressed' watercolour paper and, being board, does not need stretching.

▲ Detail of the head and beak, showing individual brush strokes.

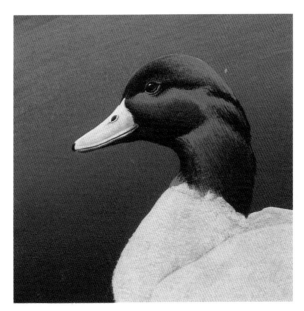

Step 2
Almost without exception David paints an undercoat of parchment colour to cover the area of the subject itself. This gives a good base for underpainting in colour or in white. He then concentrates on the eye of any bird or animal that he is painting, making it as accurate and as 'alive' as possible. Here the eye and beak are finished and the first tones of green are painted to begin modelling the head.

▲ Detail of the chest feathers.

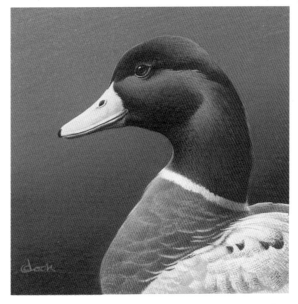

▲ *Mallard Portrait*
75 × 75 mm (3 × 3 in)
David used a size 0 round brush for painting the fine detail of the bird. The feathers were confirmed with a multitude of individual strokes using a magnifying glass.

He used a size 5 brush when he wanted to carry more paint, achieving a thin stroke by squeezing the hairs of the brush between finger and thumb and picking up the paint with this flattened brush head.

DOMESTIC ANIMALS

Guest Artist
John Lewis Fitzgerald

John's speciality is painting horses and dogs in the traditional style. In his work he utilizes the strengths of Chromacolour to the full to achieve tremendous realism and impact. He captures both the bulk and the power of horses with great finesse and the soft appealing nature of domestic pets with equal skill. The sheer lifelike quality of his work is a pleasure to see.

◀ Horse in Stable
355 × 510 mm (14 × 20 in)
John spotted this subject at a local horse trials event. It was a glorious day and the horse stood in his box, the sun on his head giving some lovely highlights with the rest of him in shadow. All that was necessary was to turn the horsebox into a stable. John used a fairly limited colour palette to achieve colour harmony.

◀ Farmyard Scene
510 × 635 mm (20 × 25 in)
John found this scene only a few miles away from where he lives in Leicestershire, but it was not quite as it appears in the finished painting. The buildings were made from breeze blocks and the windows were rusted steel. There were no animals either, only an old Landrover left there by the farmer, but with a little imagination John could see the potential in the scene. The richness of Chromacolour helped to bring the painting alive.

◄ Young Springer Spaniels
455 × 560 mm (18 × 22 in)
This painting was one of a series of dog pictures painted for a publisher to be reproduced as limited edition prints. With the amount of white on these dogs John found the covering power of Chromacolour was invaluable.

► Labrador Pup
480 × 380 mm (19 × 15 in)
Labrador puppies are very lollopy and clumsy and the way this pup was sitting conveyed that to John. The dark background was easily achieved with Chromacolour, helping the pup to really stand out.

DETAILED WILDLIFE PAINTING

Guest Artist
Chris Christoforou

The photo-realist approach to wildlife painting is very popular and offers the opportunity to painstakingly build the subject up in minute stages. This way of working requires accurate drawing ability and the main subject needs to be positioned carefully and drawn in the correct proportions. Chris is recognized as one of the country's leading exponents of this style of painting and finds that Chromacolour offers the vibrancy and clarity needed. When it comes to painting big cats Chris adopts a true 'hands on' approach, studying captive animals at close range and getting to know them intimately. If you visit him at his studio in London, beware – the sound of clicking is not his mother knitting, it is a live preying mantis, one of many small creatures he breeds for study purposes.

▶ *Watchful Mother*
560 × 815 mm (22 × 32 in)

The main approach for this painting was to create a scenario of alertness on the part of the tigress and trust on the part of the cubs that their mother will protect them from danger. Chris's objective was to reproduce the interplay of light and shade, capturing a moment in time when the animals were bathed in a shaft of sunlight that had penetrated through the shaded grass.

Chromacolour helped to achieve the objective because it is so versatile and forgiving that any technique is possible. Any area that did not work could be repainted without any fuss or complication. The colours stayed clean when working from dark to light and the opacity of the paint meant Chris could cover an area without too much 'build up' of paint.

When Chromacolour is used very thin it is excellent for glazing techniques and this helps to create subtlety and realism in the painting. The shadow on the tigress and the grass behind her are perfect examples of this. Parts of the foreground were also glazed in thin colour and then overpainted in detail with more opaque colour.

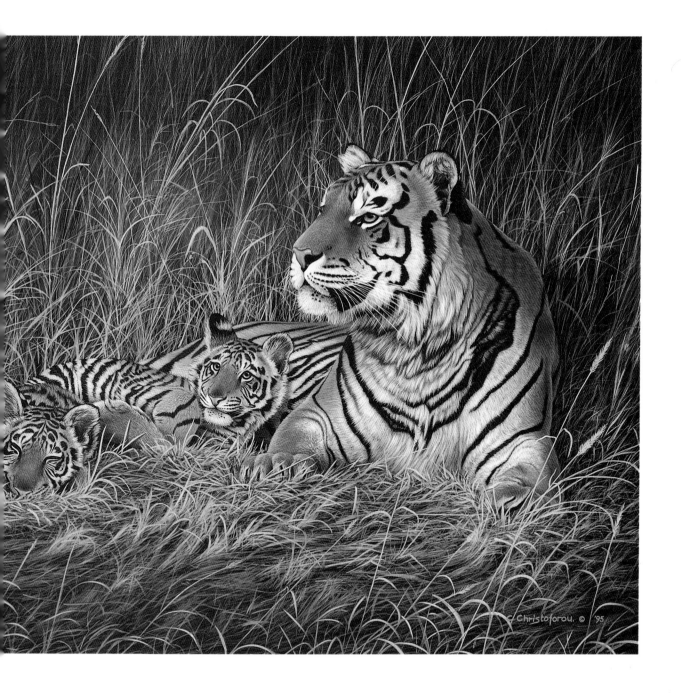

Figures and Portraits

As with animals, figures give landscapes a sense of scale or a focal point when required, but also make fascinating subjects for the artist when painted singly or in groups.

FIGURES IN THE LANDSCAPE

Adding figures to a scene can transform a very mundane subject into an interesting picture, but it is essential to have the figures taking part in some action so they really become part of the scene. Avoid putting in too much detail unless the figures themselves are the main subjects. Also ensure that they are in proportion to the rest of the picture and relate to other features of the painting in terms of perspective. Remember that they are there to give life to the landscape, not to dominate it.

Distant figures can be indicated with a light wash of Raw Sienna. As this dries, darker shading and highlights can be painted in to suggest the required shapes.

Avoid painting the feet in detail on distant figures and they will look less clumsy.

▲ An unusual viewpoint but lacking a focal point. Could this be the basis for an interesting painting?

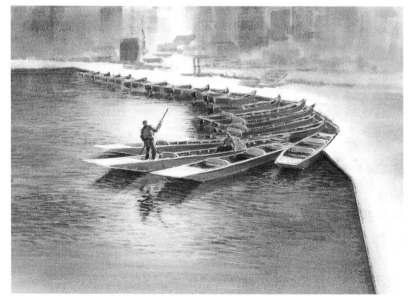

▲ *Punts on the River*
320 × 460 mm (12½ × 18¼ in)
Always look for opportunities to improve your composition. Adding figures to this view has given it interest and better balance – the eye follows a circular route, the main figure acting as a connection.

GROUPS

If your subject includes groups of figures, try to vary the size, colour and tone and arrange them in interesting clusters, some overlapping, some singly. Variation is, as usual, the keynote to a successful painting.

PORTRAITS AND FIGURE STUDIES

When painting portraits or figure studies, lighting is all-important. Frontal lighting should be avoided as it is too flat, but side or back lighting provides much more interest and detail in the subject. Photographic reference books are very helpful in this respect because the rules that guide the photographer are equally pertinent to the painter. The only difference is that as an artist you are able to manipulate the image to your own requirements and it is important to remember that you are creating an impression of what you see, not an accurate photographic image.

When placing your figure within the frame, think in similar terms to painting a vignette or still life. Be careful with the negative space around the figure and make sure that it balances the positive areas. Vary the amounts that your subject matter touches the border on each side and position the head with sufficient space around it so that there is more space in front of the face than behind. You will notice that the same technique is used in television. It is really a question of well-planned design. Where possible arrange your subject so that the light side has a dark background behind and the dark

side has a light background. A tonal sketch should establish this for you.

Give your subject room to look out of the painting and space to breathe (think of sardines to remind you). Close cropping can be dramatic, but must be intentional rather than accidental.

Find a method that suits your style. It is more important to capture the mood than a true photographic likeness.

▲ *A Short Respite Between Chukkas*
300×395 mm ($11\frac{3}{4} \times 15\frac{1}{2}$ in)
Capturing a brief incident is always more interesting than carefully posed groups.

▲ If you have trouble drawing figures (and who does not?), try this small tip. Think of your figures as a cluster of oval or sausage-shaped balloons. If you construct your basic shapes in this way it is a simple matter to draw in the clothing so that it hangs over the rounded shapes.

▲ Tonal sketch of Louise painted in Ultramarine.

FIGURE STUDIES OF LOUISE

The studies of my daughter were from a photograph taken when she was quite young. I was quite pleased with the photograph and always felt that it would make an attractive painting because of the way the strong light pouring through the nearby window brightens up the side of her face.

I was undecided whether to paint in thin or thick techniques so I started by painting a value sketch. The flexibility of Chromacolour enables you to do a value sketch in one colour to establish the tonal contrast and the finished work in either transparent or opaque styles as you wish, so I thought it would be fun to try one of each.

TONAL SKETCH

I used Ultramarine for my tonal study and tried to retain the strong light from the window and keep the calm facial expression intact.

TRANSPARENT STUDY

Using the tonal sketch for my reference now to avoid confusion, I decided to enlarge the window to improve the composition and make it less messy and I think this worked better. I hoped to keep the wistful look of innocence that I had managed to capture in the original photograph. With Chromacolour you can paint the features in any order as each layer dries waterproof. Using traditional watercolour, no doubt I would have painted the flesh tones first and added the detail later.

▲ For the transparent study of Louise, I painted an underwash of Raw Sienna, then added detail to the eyes, mouth and ear, using Raw Sienna with a touch of Cadmium Red Medium and Ultramarine. Note that the edges of the eyelids and lips are not painted completely – leaving highlights gives more life to a portrait.

▲ *Louise*
Study in transparent style
295 × 225 mm (11½ × 9 in)
I used a mixture of Raw Sienna
with a touch of Cadmium Red
Medium added to strengthen the
facial tones, and for the hair I

added Burnt Umber and
Ultramarine. I kept the garments
loose to avoid clashing with the
face and used subdued tones that
blended with the background to
retain the feeling of calm and an
air of serenity.

▲ *Louise*
Study in opaque style
305 × 255 mm (12 × 10 in)
For this opaque version I blocked
in the underpainting using fairly
thin Raw Sienna, then built up the
image using opaque mixtures of
Raw Sienna, Cadmium Red Medium
and Titanium White for the face
and Burnt Sienna, Burnt Umber
and Ultramarine for the hair. I
wanted to keep the background
subdued and used Cobalt Blue,
Raw Sienna, Lemon Yellow and
Titanium White.

My approach here is fairly
conventional, but a looser look
could have been achieved by
blending small dabs of varied
colour wet-in-wet.

OPAQUE STUDY

For the opaque study, I decided
to make the painting a little bolder
and more colourful. Like the
transparent version, I used rough-
surfaced watercolour paper and
this is where Chromacolour
scores – its ability to be used in
all styles on virtually any surface.

This makes for a massive saving
in canvas or board for the leisure
painter. No priming was
necessary, but an underwash in
Raw Sienna sealed the surface.

I used ordinary pencil for my
drawing. I could have enhanced
this with brush and paint in the
conventional style, but it is not
really necessary unless you want

your guidelines to show up more
clearly. Before starting to paint I
mixed a good quantity of Titanium
White with Chroma Gel Thickener
to thicken it, adding a few drops
of Chroma Retarder to slow down
the drying time. This proved to be
a useful mixer when used with
the various colours to create the
lighter tones I needed.

FIGURES WITH STYLE

Guest Artist
Hazel Lale

Hazel is a wonderful exponent of loose painting and her approach provides a distinctive and original way of capturing the human form. Her bold use of colour and flowing lines bring her characters to life.

Step 1
Hazel drew an outline of broken lines so washes could flow from the figure to the background.

Step 2
She kept the first wash of Cadmium Yellow and Lemon Yellow (using a size 20 round brush) moving rapidly to describe the form, accentuating the white paper highlights. Some Cadmium Red Medium was painted on the face and headscarf, and through the arm, and while this was still wet Burnt Sienna mixed with a little Burnt Umber was pushed into the face and arm, threading it through into the basket and allowing it to diffuse into the background.

Step 3
The whole process was kept moving quite rapidly and several washes were laid down before the painting dried.

Step 4
Hazel next put in the local green colour of the woman's dress and painted some of this into the background, suggesting foliage. Remembering that intense light depletes and obscures pattern, Hazel kept some detail in middle value colours. She mixed Burnt Umber, Ultramarine and Alizarine Crimson and painted in the shadows, allowing this mix to fuse with existing overwashes and create hard edges on dry glazes. She decided which parts of the painting needed re-emphasizing with thicker paint.

▲ **African Figure with Basket**
760 x 560 mm (30 x 22 in)
While many of the initial glazes had dried but some of the impasto mixes remained wet, the painting was immersed in water and gently agitated. The wet paint lifted off, leaving only the dried glazes, producing a multi-faceted image with great depth. Hazel allowed the paper to begin to dry and with a size 9 brush reinstated some local colour and put in the broader details. She used a size 1 brush to emphasize facial and fine detail.

PORTRAITS AND GROUPS

Guest Artist
Dennis Hill

Dennis paints colourful figures and portraits in traditional style but with loose, economic brush strokes. As a result his work has a freshness that is further enhanced by the use of Chromacolour.

▲ *Carolyne*
Portrait in transparent style
370 × 520 mm (14½ × 20½ in)
This was a Chromacolour copy of an existing watercolour portrait painted from a live model. Dennis took a great deal of care in his drawing (about 45 minutes), carefully indicating the features in the correct proportions and making small marks to get the geography right.

The painting took about the same length of time and he worked quite rapidly, starting by flooding the features and part of the hair with Raw Sienna. Modelling was added into the damp paint with Ultramarine and Burnt Sienna. Shadows on the features were painted with Raw Sienna, Prism Violet and Alizarine Crimson. Using the same mixture, the dried surface was glazed over to add modelling, leaving some edges hard and softening others. The background and clothes were painted last.

▶ *The Woodworker*

Portrait in opaque style

360 × 405 mm (14¼ × 16 in)

Painted from a live model, Dennis's colours were Raw Sienna, Cadmium Orange, Cadmium Red Light, Alizarine Crimson, Burnt Sienna, Cobalt Blue and Titanium White. He primed the watercolour board with three coats of Chroma Gesso Primer, the second one mixed with texture paint. This is the same procedure he uses prior to working with oil paint and gives a good tooth to the surface. The outlines were painted in with a brush using Burnt Sienna and a thin wash of Raw Sienna was applied. Dennis enlarged the board at the bottom to improve the picture's composition.

▶ *Beachday*

Opaque beach scene

230 × 330 mm (9¼ × 13 in)

This was based on a pencil sketch and Dennis used the same colours as for the opaque portrait plus Cadmium Yellow Medium, Prism Violet, Magenta Medium and Cerulean Blue.

First he worked on the centre of interest – the form of the large sailing boat – after which he roughed in the sea, sky and beach. Then he painted the figures – larger in the foreground and smaller in the distance – arranging an interesting group around the boat. Warm shadows were painted using Raw Sienna and Prism Violet. Finally detail was added to the sky and sea, and the sand dunes and grassy banks were painted.

Dennis found that having a pool of Chroma Retarder on the palette and just dipping the brush into it was the answer to producing soft edges. Where he felt the colour needed to be a little warmer, he used a few thin glazes.

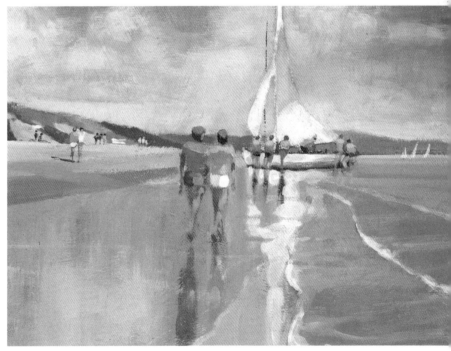

Suppliers

Chromacolour paints and other materials can be obtained direct from the manufacturer or from selected retailers. For a full list of these retailers, for more information, or to place an order direct from anywhere in the world, please contact one of the following addresses:

Chromacolour International Ltd,
11 Grange Mills,
Weir Road,
London SW12 0NE
UK
Telephone: 0181 675 8422
Fax: 0181 675 8499

Chromacolour International Ltd,
2, 3434 34 Avenue N. E.,
Calgary,
Alberta T1Y 6X3
Canada
Telephone: 403 250 5880
Fax: 403 250 7194

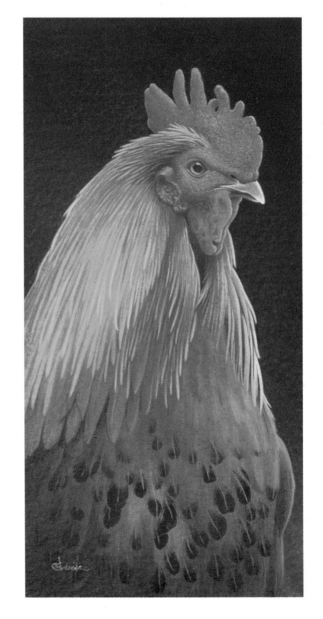

David Cook, *The Cockerel of Perth*,
150 × 75 mm (6 × 3 in)

94

Index